COLOR BYTES

Blending the Art and Science of Color

CHROMATICS PRESS

FOREST HILLS, NEW YORK

ISBN 1-888551-00-3

CHROMATICS PRESS, INC.

110-64 Queens Blvd. Suite #268
Forest Hills, NY 11375 Tel. 718-793-1464 Fax 718-793-2857

*For all markets, (except educational) including book clubs, direct mail and corporate sales., and
other territories contact:* CHROMATICS PRESS, INC.

I want to express my thanks to all the people who helped bring this project to a successful
conclusion. Special acknowledgments go to Marilyn Scheyer, our designer; my sister, Janet Silver
Ghent, who dealt patiently with all the editorial tussles; and the indomitable Jean Bourges whose
spirit spawned the seeds for this work, spending nearly a decade organizing its publication.

I worked on this book for nearly three years. For a time, I doubted it would ever be completed,
but in the end, sanity prevailed. I want to thank all the distributors and companies that waited
patiently for the book's arrival. Your indulgence should be rewarded. The book takes a
decidedly artist's point of view and does not delve thoroughly into the technical aspects of
computer use. It does, however, make tremendous strides toward reconciling the art and science
of color and will undoubtedly serve as a invaluable teaching tool.

On a personal note, I want to pay special tribute to my father, Robert M. Silver, who at the age of
eighty, can look back at his numerous accomplishments in publishing with great satisfaction and
take pride in knowing that both his children went on to serve the industry he helped pioneer.

Robert E. Silver, *Chromatics Press, Inc.*

ART DIRECTOR Jean Bourges

DESIGNERS Elaine Condon, Karen Williams

ARTISTS Durell Godfrey, Steve Hetzel, Marilyn Scheyer, Karen Williams

PREPRESS PRODUCTION Marilyn Scheyer, Multi Media Design

EDITORS Janet Silver Ghent, Diana Guerriero, Debbie Hagan

PRINTING & PRODUCTION Quality Graphics Center, Inc., Roselle, NJ

PRODUCTION COORDINATOR Meggan Trinidad

MEASUREMENTS Iain Trevor Pike, X-Rite, Inc.

COLOR BYTES

by *Jean Bourges*

*"The purest and most thoughtful
minds are those
which love color the most."*

John Ruskin, *The Stones of Venice*

This book is dedicated . . . to the grit and determination of the whole Bourges family, at least the four generations whom I know. In addition to my grandfather and the "Bourges boys", shown on this page, there are my mother, Jessie, the idea artist of the 20's, my Aunt Myette, the fashion designer from Paris and my two fine sons, Richard and John Bourges, who are always there when I need them . . . and who somehow understood that their mother has a strange and wonderful passion for the subject of color.

Joseph Bourges and sons; Albert at left and Fernand at right

Next, I must say what a great challenge this has been to co-publish my book with Chromatics Press. This was a new venture for them and they deserve a great deal of credit for taking on such a radical new concept in the conventional art world.

A special acknowledgement to the following who have led, advised, and supported my work exploring this elusive subject of color. First of all, there is Dr. Louis Sipley, my first mentor; Charles Temko, the lawyer who got my first two color patents; and Tom Adams, another legal knight who fought many good fights to protect this heritage; John Jenkins, who kept me focused on a practical business plan; and my dear friend Elaine Condon, who is in effect the godmother of this book who never doubted for a moment that it would be published and be a credit to all.

There have also been many wonderful people along the way who have helped supply an important piece of this puzzle and deserve a special mention here: Frank Abad, Frank Arnold, and Mike Galligar, who did the earliest testing and proved the concept worked; Roger Pitt, who did some of the early writing for this text; Mark Golden, who made the first tests for art material colors; Bob Rose, that savvy print expert who was surprised when he checked the reflectance data, to find that it worked for technology as well as it did for art; Dr. Joel Pokorny and Dr. Jay Cohen, who confirmed the importance of defective color vision; Wayne Perry, who did the original digital proofing…and any others I may have inadvertently omitted, you are not forgotten.

My deepest appreciation to all of you; the wonderful joy of seeing this book finally in print, is also yours. J.B.

Unlock the Magic

Color is a magical element that gives feeling and emotion to art and design. It is an elusive subject, and yet one that has been here since the world began. This book is designed to grab hold of color in all its glory, reveal its secrets, and provide an understanding of how and why it works.

Color Bytes may sound like computer talk, which in a way it is; all the information is brought to you electronically. This art and text were generated by computers and the latest digital controls were applied for economy and accuracy.

What is color? Is it art or science? Truly it is both. It works simultaneously on many levels and that is at the core of the mystery, for color is not a simple subject. In fact, it was the master artist Delacroix who saw no reason for studying color because he thought it was only of interest to artists and they already knew what it was.

Now many people want to know about color and how to use it wisely. Even the best artists today would like to have a real structure similar to what exists in music; it is important not just to create colors but to convey them accurately to others in words, numbers, and appearance.

How to choose colors? Every color can be beautiful, but beauty alone is not enough. What does the color say? Here is a familiar designer's palette with psychological profiles for each color. The masters learned how colors worked together from years and years of personal experience. *Color Bytes* gives simple guidelines for warm and cool combinations, complements, and multicolor harmony…not chaos.

This book is about the *process* rainbow, similar to nature's own, which is about light. This story is about pigments, paints, inks, and other colorants, which are the ways most of us think about color. *Color Bytes* takes another giant step forward and addresses the subject in process terms. The language is familiar, the art fundamentals are ageless, this connection to CMYK is patented, and the colorimetric references are state of the art. This digital rainbow is a mystery no longer. In a simple visual manner, the magic is explained.

Come explore, learn, and enjoy.

COLOR BYTES

CONTENTS

CONTENTS

Color Was Always Here

Technically someone had to be there to see it, but if the big bang theory is correct, it must have been in color. Even though no one knows exactly what it looked like, one can imagine it as a fireworks display of heavenly measure, showering space with flying fireballs and glowing comets. Out of all this, the sun formed and with it came light.

Considering that color is as old as time, then why are we still struggling to define it and establish a logical system for using it? The answer is simple; color was always here, but it is both complex and taken for granted.

Primeval humans gave no more thought to color than to the air that they breathed. Surrounded by green oceans, blue skies, red volcanic fires, and golden sunlight, they associated color strictly with survival. An orange or red glow on the horizon meant the sun was going down and they had to return to their shelter. A

Professor Gunnar Tonquist, Combi Visuell, Sweden
Courtesy Lidman Productions©

red berry in the bush meant the fruit was ripe and ready to eat.

Primitive people mostly created weapons and cooking utensils, but we now know that they also painted. Inside the French Lascaux and the Spanish Altamira caves are realistic renderings of animals that date back to 15,000 B.C. The paintings are of buffaloes, rhinoceroses, deer, horses, boars, and wolves. Humans were rarely depicted and then only as simple graphic shapes.

The reason the artworks have survived all this time is that they were created in the deepest and darkest recesses of the caves, far from any light sources. Judging from the inaccessibility of the paintings and the difficult lifestyle of these people, scientists speculate that cave dwellers created their shelters for functional rather than for aesthetic purposes. Unable to differentiate between reality and illusion, the cave people may have thought that by trapping an animal on a wall, they had in fact captured it.

This red-hearted woolly mammoth illustrates an effective use of color. The cave paintings were created in warm earth colors, made from chunks of red and yellow ochers contained in iron oxide. Some ochers were ground into powder and blown upon the walls. Others were mixed with animal fat and painted over the stone walls using a reed or bristle.

Without any sort of written language, early humans used their art to communicate and magically control a world that they really didn't understand. Their drawings could be considered the beginning of graphic communications.

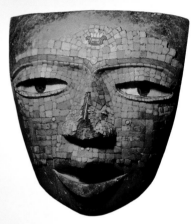

Courtesy of Professor Peter T. Furst

After people learned to grow crops and domesticate animals, they had time to develop their imaginations further. They expressed ideas on architecture, government, law, and religion, and began forming civilized societies. They expanded their artistic talents beyond painting, and began designing with fabrics, metals, clay, chalk, and semiprecious stones. The mosaic mask pictured here is a perfect example. It is made of coral and turquoise chips. In contrast to the realistic works of the cave dwellers, this mask and many of the statues and objects made at this time portrayed spirits that would protect people from harm and frighten away demons.

Jewels of the Dark Ages

Between ancient and modern civilizations is an epoch (400-1400 A.D.) that is often considered gloomy, unrefined, and culturally stagnant. It is known as the Dark or Middle Ages.

The complex, intricate features of the Gothic cathedrals were designed to enhance meditation and inspire individual devotion, these colossal buildings often took entire towns centuries to complete. The flying buttress, a characteristic Gothic support mechanism, provided exterior strength to spacious interiors and soaring rib-vaulted ceilings.

Though we still marvel at these architectural accomplishments, the monumental stained glass windows designed for these spaces are just as amazing. Some of the churches most

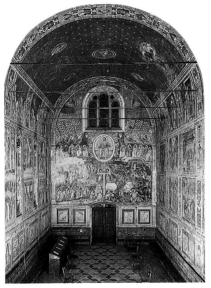

Giotto's Frescoes-1305 *Life Magazine*, Dec. 20, 1948
PHOTOGRAPHER Fernand Bourges

famous for their rich, jeweled-glass windows are Notre Dame (particularly the rose window), Chartres, Reims, and Saint Etienne, also known as the Bourges Cathedral. Like the illuminated manuscripts, these windows illustrated stories of faith as well as the breadth of regional crafts and trades. As the sun moved across the sky, the windows became ever-changing color spectacles.

In the late thirteenth and fourteenth century, Italy witnessed the pre-dawning of the Renaissance. Giotto di Bondone (1266-1337) departed from the stereotypical, dignified, and impersonal Italo-Byzantine style, creating human forms that were more natural, rounded, and sculptural. Giotto's style is clearly seen in the well-preserved frescoes of the Arena Chapel (1304-1313) in Padua. The scenes on the walls are full of passion, and the stories are so vividly depicted that viewers sense that they are involved in the action rather than observing it. Like today's epic movies, the panels tell their stories scene by scene.

Taking Giotto's lead, book illumination also changed. By the end of the thirteenth century, illuminated flowers, vines, animals, and characters proliferated on the pages, seeming to grow over the text. This occurs in the beautifully illustrated Book of Hours, (*Belle Heures*) made for the personal use of royalty and the wealthy families in Europe. Each book was a valuable treasure, created by many artisans. The script was hand-lettered, the imagery painted by skilled artists and many were encrusted with precious jewels.

As more and more artists and philosophers began deviating from the secure, well-worn paths taken by their predecessors, the darkness of the Middle Ages subsided and a new age burst forth in full color.

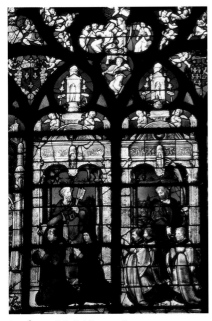

Saint Étienne Cathedral, Bourges , France
PHOTOGRAPHER Nadine Moreaux, Mairie de Bourges©

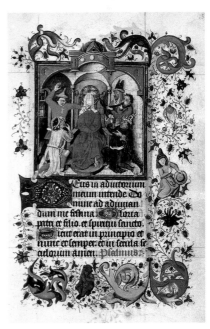

Book of Hours, Pierpont Morgan Library Collection©

Glory Days

Like the great flood that ended allegorically with a rainbow, the Dark Ages ended with a burst of color, a renewed sensitivity to the world and all its beauties. The Renaissance, the period between the fourteenth and sixteenth centuries, was a time when not only nature was glorified, but humanity as well. The weak and fallible individual was now regarded as worthy of depiction in the arts.

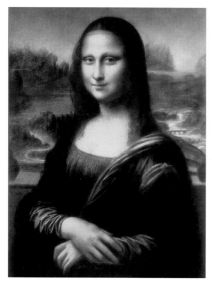

Leonardo daVinci, *Mona Lisa (La Gioconda)*, 1503-1506
Reprinted by permission of Musée de Louvre, Paris

In part, this explains why so many artists made great achievements in both the arts and sciences. The archetypal Renaissance man was Leonardo da Vinci (1452-1519). Though he is primarily known for his painted masterpieces, including *The Last Supper* and *Mona Lisa (La Gioconda)* he created only 30 paintings in his lifetime. A genius, Leonardo devoted much of his time to studying anatomy, botany, zoology, light, optics, and color, and to sketch-ing these subjects in detail.

Such a thirst for knowledge, originating in Italy and spreading throughout Europe, renewed interest in classical studies. In Italy, artists painted with fresco, but in the north, they used oil paints. In Germany during this period, Albrecht Dürer (1471-1543) was a master painter who was actually better known for his wood cuts and engravings. Familiar with printing and a teacher at heart, he can truly be called a fifteenth-century graphic designer.

In Florence, Michelangelo Buonarroti (1475-1564) was another inspired genius and universal man. An architect, painter, poet, and engineer, he considered himself first and foremost a sculptor. Influenced by sculpture, Michelangelo glorified the human form and used it to heighten the drama in his paintings. In essence, this artist advanced Giotto's style by imbuing his work with emotion.

Like Giotto before him, Michelangelo painted frescoes directly on walls and ceiling. Unlike Giotto's humans, Michelangelo's Sistine Chapel figures are Herculean and their tragic splendor is carefully devised to wrench the observer with passion. Apart from the chapel's size and artistic magnificence, the fact that the artist started this project when he was sixty-one years old and completed it in just four years, under extremely difficult working conditions, makes it one of the greatest achievements in world art history.

Michelangelo, like other artists of his time, was also a chemist. He mixed his own pigments from natural ingredients, including bugs, snails, urine, minerals, semiprecious stones, and clay. Each artist developed his own secret paint formulas and carefully protected them.

Expert cleaning and restoration of the Sistine Chapel show that Michelangelo actually painted with pure, bright colors. For centuries, the colors were concealed behind layers of mold, grime, and dust. Heat and smoke from candles, humidity, and environmental pollutants also distorted the colors and darkened the varnishes. It was assumed that the muted hues were intentional. However, careful study now reveals that the sky areas, which are hardest to restore, were originally painted with two layers of brilliant blue pigment, made of crushed lapis lazuli.

Light not only entered the Renaissance mind, but the artist's palette too, bringing art to yet another new plateau.

Michelangelo, *Ezekiel*, Sistine Chapel, 1508-1512

SHADOW Adds Another Dimension

Beginning in the seventeenth century, art entered a dynamic new phase, known as the baroque period. Colorful, theatrical, passionate, and lavish works characterize this style. The grand, glorious Renaissance style was brought down to the human level. Illusionism, light, and color were manipulated so that viewers could better share the joys and sorrows of the art subjects.

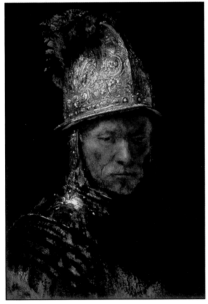

Rembrandt van Rijn, *Man with the Golden Helmet*, 1650

Before the baroque period, flat, neutral light illuminated the faces of art subjects. Now artists began making finer and finer distinctions between light and shadow. This became known as chiaroscuro, a term that combines two Italian words, *chiaro* (light) and *scuro* (dark). In essence, artists manipulated light and dark in order to give their subjects shape, the illusion of depth and dimension, even though they were painting on a flat surface.

Rembrandt van Rijn (1606-1669) was considered a chiaroscuro master. One of the greatest artists of his time, he heightened the sculpted look of his subjects by lighting them from spe-cific sources emanating from beyond the painted canvas. It was as if he shined a spotlight upon the scene. Beyond his use of light and dark, Rembrandt painted with a wide range of in-between grays and muted colors, giving his work even more of a three-dimensional look.

Coinciding with this art movement was a new science that redefined the universe. Astronomers and physi-cists such as Galileo Galilei, Sir Isaac Newton and Johannes Kepler began explaining the mysteries of light, color, gravity, and the solar system. This period became known as the Age of Enlightenment. Science moved out of the sphere of shamans to that of learned scholars whose experiments substantiated their theories. This new knowledge not only changed history, but altered the way artists perceived and interpreted their world.

Music and Chemistry

Without musical notes, an early musician could not organize the melodies in his head so others could play them. Before recording devices were invented, auditory delights vanished as soon as the musician stopped playing. As a result, musicians sought to find a way to write down tones so they could be universally replicated.

Though musical instruments were around as early as 4000 B.C., a system that organized their range of sounds came later. A five-tone musical scale was established in China around 2000 B.C. The Greek philosopher Pythagoras (who died around 497 B.C.) is credited for instituting the octave, and Aristotle, around 340 B.C., laid the foundations for musical theory. In 1026 A.D., Guido d'Arezzo introduced the *do re mi* to music. By 1558, when Gioseffo Zarlino added major and minor scales, a system for organizing music was in place. Over the next century, modern harmony was refined with counterpoint, modulation, and instrumentation. Though the musical notation system that we use today took a long time to develop, without it we would have lost the works of Mozart, Bach, Beethoven or anything that required *written* music.

Sir Isaac Newton paid homage to music's structural system by drawing relationships between the colors that he discovered with his prism to specific notes of the tonal scale.

Newton's Notes

C – do	red
D – re	orange
E – mi	yellow
F – fa	green
G – sol	blue
A – la	indigo
B – ti	violet

LIGHT IMPRESSIONS

The Enlightenment period led to a resurgence of scholarship and spawned the development of many new art movements.

Probably the most significant was impressionism. This style, championed by a group of Parisian artists, was a major departure from all previous styles. These artists studied some color science and sought to depict what they saw truthfully, rather than paint by traditional artistic rules. Their aim was to

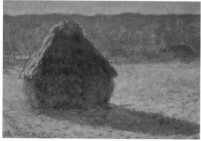

Claude Monet, *Grain Stack, Snow Effect, Morning,* 1891

capture an optical impression of light and atmosphere by strategically placing dabs of primary unmixed colors in their work. This was in part possible because of the invention of collapsible tin tubes (1841). Before then, artists stored their paints in pigs' bladders!

The leader of this group was Claude Monet (1840-1926), who is responsible for advancing this style the furthest. In 1888, he began painting single subjects as seen in varying degrees of light, capturing his impressions of the object at different seasons and times of the day. The essence of his painting theory was that since colors do not emanate from an object, they come from

reflected light; it is light that influences the way that we perceive an object.

In the fields near his home in Giverny, Monet painted common grainstacks. He created 25 of these studies, all from practically the same point of view but in different forms of light. The result is haystacks ranging in colors from cool purplish tones to hot ocher, pink, and alizarin.

Because there is no black in the spectrum, Monet used no black or gray in his paintings, even in the shadows. For these areas, he blended pure colors. Throughout his lifetime, Monet continued to analyze light and color and the way we are influenced by them. He became more deeply involved in this theory, resulting in work that was practically abstract by his career's end.

"Instead of trying to reproduce exactly what I have before my eyes, I use color more arbitrarily so as to express myself forcibly," wrote Vincent Van Gogh (1853-1890). Essentially he defined the postimpressionist movement. Unlike the impressionists, Van Gogh did not lighten his palette. Instead he used

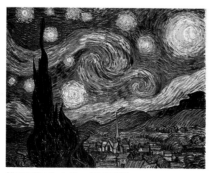

Vincent Van Gogh, *Starry Night,* 1889
PHOTOGRAPHER Fernand Bourges

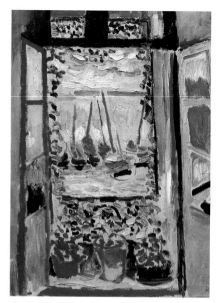

Henri Matisse, *Fenetre Ouverte, Collioure (The Open Window),* 1905
Courtesy of the Mrs. John Hay Whitney Collection

contrasts to heighten the mystery within his work. In *Starry Night* (1889), he placed vivid, passionate light against a somber, morose background.

Following Van Gogh was a group of artists known as fauvists. They also sought to express themselves through color but with even purer, brighter, and often dissonant hues. Henri Matisse (1869-1954), at the center of this movement, used colors, instead of grays, to convey light and shadow. He sought to return to the simple, expressive power in Giotto's fourteenth-century paintings.

In some sense, art gradually returned to almost where it began, placing value on the subject's pictorial and symbolic essence. Since the techniques for making subjects more realistic had been mastered, artists began searching for other new challenges. Thus, they moved on to express themselves in more and more abstract terms, in styles ranging from cubism to minimalism.

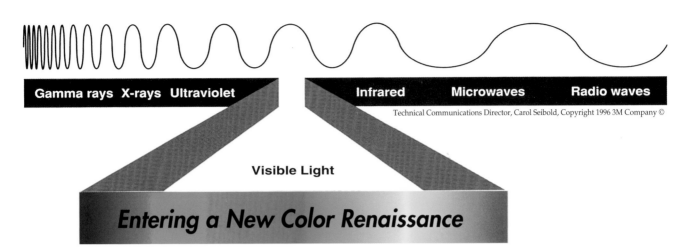

Gamma rays X-rays Ultraviolet

Infrared Microwaves Radio waves

Visible Light

Entering a New Color Renaissance

Color has gone through a long history of changes in styles and techniques, so one wonders where exactly we are today. Even though color was with us since time began, are we any closer to understanding it and developing a system to define and use it?

Through science, we have learned a lot about color. Research has proven that color does not come from spirits nor from objects. It comes from reflected light; white light, when separated by a prism, a diamond, or a water droplet, results in a rainbow, known as the light spectrum.

In addition, light reflected from an object can also be accurately measured by scientific instruments and numerically described. Thus, all visible colors can be defined and matched. This is an incredible break-through for scientists and artists.

For the artist, the possibilities seem limitless. No longer are artists restricted by their materials. They don't have to paint on damp walls or animal skins or waste valuable creative time grinding stones and crushing bugs to make their pigments. Excellent art materials are available at local art supply stores and/or

accessible with a color computer. By doing little more than pushing a button, virtually any color imaginable can be at the artist's fingertips.

After producing their work, artists are now assured that the integrity of their creations will be preserved in graphic reproduction. Because colors can be identified and measured, they can also be precisely matched. While printers, artists, and scientists have had difficulty in the past making themselves understood to one another, the computer has linked them all together. No longer does the artist need to be a Michelangelo or a Leonardo da Vinci to be a modern Renaissance individual. With today's

art materials and a computer, the artist's capabilities can go further than ever dreamed possible.

Proper color selection and usage are good places for most artists to begin familiarizing themselves with the new technology available. *Color Bytes* not only serves as a companion in helping artists understand the connection between the purpose of their art and the colors they choose, but it is directly tied into today's creative art techniques and electronic technology.

A new renaissance is coming with the reality of written color and it promises a more colorful future for everyone.

CLIENT NEC Technologies AGENCY DDB Needham Worldwide ILLUSTRATOR Dale Verzaal

LIFE with COLOR

Color was as much a part of my childhood as sandlot baseball or scouting is to other children. My father, Albert Bourges, owned and operated an engraving plant. As a result, the most frequent topic of conversation in our house was matching colors. When there were problems, my father blamed the inks. My uncle, Fernand Bourges, a pioneer in color photography, faulted the dyes. And my mother, Jessie, didn't always know why the colors didn't work, but she instinctively knew whether or not they did. Thus, I learned to see color from

three distinct viewpoints: the engraver's, the photographer's, and the artist's.

At the turn of the century, my father entered the graphic arts field as an apprentice to a wood engraver in Chattanooga. Soon he wanted to know more about the printing trade, so he set out traveling up and down the Mississippi River as a hobo engraver. He stopped at engraving plants along the river highway and worked in all departments, learning as much as he could. During the 1904 World's Fair in St. Louis, he settled at Sanders Engraving, where he learned the new process of photomechanical plate-making. Through the local graphic arts trade, he met my mother, a self-trained artist, who worked for Sanders' competitor, Barnes Crosby.

Then my father ventured on to Chicago, where he opened an office in the Rand McNally Building and free-lanced, specializing in color

etching and finishing. One of his clients was the Ruxton Ink Company, where he became fascinated with color and searched for orderly solutions. At last my father fulfilled his lifelong dream of moving to New York City, the pinnacle of the graphic arts field where important changes were taking place. There he opened his own plant and soon moved to the Flatiron Building (*see Page 15*).

A short time later, he sent for my mother, and they were married in the Little Church Around the Corner. She began working as a commercial artist in New York City's art studios. I will always remember going to Warsaw's on Saturdays, when the artists were producing catalogs. They worked quickly, around the clock and in an assembly-line fashion. One artist drew figures. Another drew shoelaces. Another backgrounds, and still another retouched. To a child's eyes, this was fascinating.

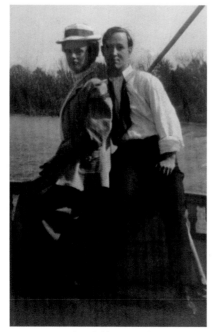

Jessie Delahunt and Albert Bourges, 1904

Barnes Crosby Engravers, St. Louis, 1904

Dad was more than just a photo-engraving trailblazer. He was also a color theorist, a researcher, and an inventor. In 1918, he organized colors by numbers. This was known as the Bourges Color Notation System. It was widely acclaimed and earned him considerable respect in the graphic arts field. He wished to continue his research, but subsidizing it was a problem.

For this reason, my father developed marketable products that were financially successful. In the 1920s, he introduced modern opaquing pens and Bourges Artists Shading Sheets, which were line patterns printed on transparent or italic celluloid carriers.

Before his invention, line patterns had to be transferred directly to the printing plate with Ben Day screens, a licensed process used only by engravers. Bourges sheets, by contrast, were designed to be used by the artist, who could try out different

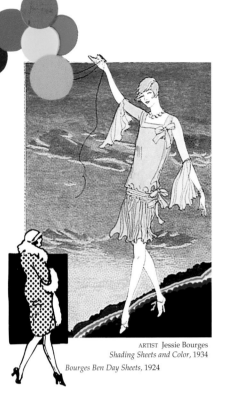

ARTIST Jessie Bourges
Shading Sheets and Color, 1934
Bourges Ben Day Sheets, 1924

patterns and then apply the sheets to the original art copy. However, the Local Photoengravers' Union, which had jurisdiction over the Ben Day process, took the stance that artists were meddling in jobs that belonged to photoengravers. Even though artists responded enthusiastically to the sheets, some engravers refused to work on projects made from this product. As a result, my father often ended up making plates for his artist customers. After a long fight, the union relented, and the first artwork that it accepted was the popular *Maggie and Jiggs* comic strip, which appeared in the Hearst papers.

As fate would have it, an explosion occurred in the basement of the Flatiron Building, where the celluloid sheets were stored. Manhole covers were blown into the air, across Fifth Avenue. Fortunately, no one was hurt, but nearly everything in my father's plant was damaged.

Even that didn't stop Albert Bourges. He continued working as a consultant for such companies as the *Baltimore Sun,* The *Toronto Star,* and Oklahoma Publishing. His major account became Time Life Research, but when the company became Printing Developments Inc. (PDI), my father decided not to move to its new official headquarters in Stamford, Conn.

Instead, he chose to continue making products. There had been a lot of interest in the color sheets that he had experimented with in the early '40s. So he said, "It's time to put real printing-ink colors into the hands of the creative artist." That's when he asked me to join him, and together we launched a new business, manufacturing and marketing these first color sheets. What they achieved was shown at Bourges '61, a seminar and exhibit at the Society of illustrators, New York City, May,

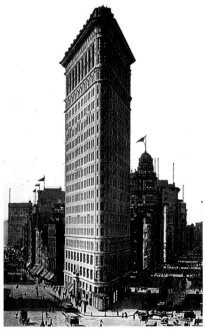

Flatiron Building circa 1920

Traveling Exhibit *Art To Print*

100 *Years of Separations*

One hundred years ago, exploration and homesteading of America's wild and woolly frontier was complete. This enabled our country to turn its attention to the twentieth century, which promised to be a new age of technical discoveries. Already Henry Ford had built his first car. Marconi had introduced the wireless telegraph. Thomas Edison had introduced the first phonograph. In Paris, Auguste and Louis Lumière received their first patent for a motion-picture camera.

Simultaneously, New York portrait photographer William Kurtz revolutionized the photomechanical field. After long experimentation, he created the first successful three-color photoengraving. When it appeared in *The Engraver and Printer* of Boston in 1893, the world was amazed. A year later, Joseph Pulitzer installed a four-color rotary press, which was used to print the Sunday supplements of the *New York World*.

In the 1920s, my father was commissioned to separate and reproduce paintings that were mounted high on the walls of the U.S. Naval Academy in Annapolis, Md. Using his own color notation system, he recorded information about the hues in the artwork. He wrote down each color in the paintings, as it corresponded to a number in his system. For instance, Color No. 1 was 20% red, 100% yellow and 30% blue. Color No. 12 was 80% red, no yellow, and 70% blue. He made all his notations by sight, comparing the colors to his process charts. When he returned to his engraving plant in New York City, he used just a black-and-white photograph and his notes to render the engravings. The end results were high-quality, well-received reproductions that were reprinted in Pulitzer's *New York World* gravure color supplement.

In 1920, the Art Directors Club of New York hosted its first show and awards presentation. Some say that Hollywood's Academy Awards ceremony, which debuted seven years later, was patterned after this highly prestigious, glitzy affair. The painting, *Carmen*, by W.E. Heitland for the Columbia Gramophone, was a first-prize award winner that year. The separations for it were made photomechanically by Bourges Service Engravers.

In the 1930s, the art of color repro-

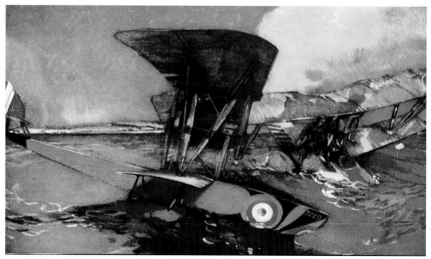

ARTIST H. Townsend, *Navy Painting, An Air Rescue* 1917 ,Color Reproduction by Albert Bourges, 1921

ARTIST W.E. Heitland ENGRAVINGS Bourges Service, Inc.
Winner Art Directors Club Exhibit, 1920

duction leaped forward when Condé Nast published *Color Sells* to promote quality color photography as a viable advertising medium. In doing so, the publishers brought in the keen, creative eyes of two top-notch experts: Anton Bruehl, artist-photographer; and Fernand Bourges, my uncle and a skilled photoengraver. The two men worked separately to ensure that the photographs, taken at shutter speeds of 1/50th of a second, retained all their original elements of good art form: harmony in composition, balanced color values, and effective contrast. Even then, there was an astute awareness that artistic thought and technology must be linked in order to produce quality results.

But few companies could afford the kind of investment made by Condé Nast. Certainly the need and demand for color were great, but the costs were often prohibitive,

particularly for comics, children's books, and other short-run projects. Developing a cheaper way to use color, some printers created fake separations by using black opaque overlays. However, the quality was inferior and visualizing the end results, especially when overprinting colors, was nearly impossible.

The Bourges sheets, made in transparent ink colors, could also be photographed accurately on black-and-white film using color filters. By the '50s and '60s, many artists were doing their own color separations. These color sheets were also used as removable filters for the correction of color transparencies.

Just as the twentieth century was the era of photographic imagery, the twenty-first century promises to be the age of electronics. Computers have already brought enormous changes in our work as well as

personal lifestyles. These changes will become magnified in the next 100 years. The challenge now is to follow the example of Condé Nast and find a compatible way of linking this new technology with the creative skills of the artists.

PHOTOGRAPHY Fernand Bourges-Anton Bruehl, 1935
Courtesy of Condé Nast Publications, Inc.

DIGITAL PHOTOGRAPHY C.E. Rinehart, Eastman Kodak Co., 1988

BASICS OF BOURGES

*A full spectrum
of artists' colors
anchored in
color space.
A new palette
of familiar colors
with guidelines &
measurement data;
connecting the art
to computers
to print on paper.*

Bourges Divides Color into FOUR Parts

Scientists now tell us that we can measure and match virtually billions of hues, magnifying the problem of color selection. To simplify our understanding, this system divides all hues into four basic groups. Even primitive cultures associated meaning with color and used four different colors to represent the directional points of the compass. Later, philosopher Aristotle and master painter Leonardo da Vinci believed these same colors symbolized the earth's basic elements: fire, water, earth, and air. In this system, colors are related to four aspects of the human psyche.

REDS *MAUVE, MAGENTA, CRIMSON, SCARLET, POSTER RED**

Red is blood. It is symbolic of highly charged personal feelings and acts such as aggression, danger, battle, bravery and love. When we say that someone "sees red," he or she is angry. When someone is described as "red-blooded," he or she is passionate. Packed with so much emotion, reds are the most frequently used colors in creative arts. Red alerts us to pay attention, and says, "You're seeing something special." Reds convey emotion and are the first colors to catch the eye. Red was the first word developed in any language to define a particular color; it's a fitting place to start the Bourges System.

YELLOWS *CORAL, ORANGE, AMBER, GOLD, YELLOW**

Yellow is energy. Throughout history, the world's power resource has been the sun. Each day it can start off as a pale glow, turning to yellow gold at midday and becoming blazing orange by sunset. After its sojourn across the sky, it disappears. Imagine the apprehension of primitive humans as they pondered whether their only source of light and heat would return. Thus, we associate yellows with uncertainty and restlessness. And like the flames of the fire that warms us, it also warns us to be cautious. Never peaceful, *yellow* is the color of ideas and dreams. It stimulates those with creativity and confidence.

**All 20 Bourges Profile Colors will be italicized throughout the book.*

ARTIST Steve Hetzel

GREENS
LIME, LEAF GREEN, SEA GREEN, EMERALD, TEAL*

Green is life. Foliage, trees, and blue-green waters cover our planet, giving it a verdant look. To live and survive, plants depend on a green coloring matter known as chlorophyll. Through photosynthesis, sunlight is absorbed by the chlorophyll in the leaves, enabling the plant to receive nourishment and grow. Green is sensuous and alive. It is the grass under our feet and the salad greens and vegetables that keep us healthy. So when ecologists talk about the "greening of the world," we envision a healthier, happier planet. Greens are friendly, dependable, and steady, like Mother Nature.

BLUES
CYAN, SKY BLUE, ULTRAMARINE, VIOLET, PURPLE*

Blue is peace. Like a security blanket, the blue sky above us is calming and tranquil. After the icy hue of winter or threatening *purple* storm clouds subside, soon the beautiful azure blue returns, reminding us that the sky is a dear old companion. Who hasn't gazed up at the placid blue sky and felt, "All is right with the world"? Blue is not a color we can easily embrace. It's in the distance, remote. We respect it as a sign of law, order, and logic. Instead of ending with ultraviolet and blackness, this spectrum ends with *purple,* the reddest of the blues, which connects back to *mauve* at the beginning of this system.

All 20 Bourges Profile Colors will be italicized throughout the book.

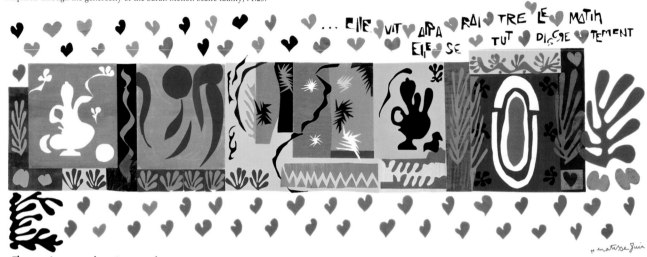

The text in cut-out lettering translates...

"She saw the Light of day/She fell discreetly silent." The composition of this work reinforces its narrative, Arabian-Nights theme, the passage of a single night prolonged by story-telling, moving from a Persian lamp burning at night through complex fictional sequences to an image of dawn, when the narrator finally "falls discreetly silent."

Henry Matisse: A Retrospective, September 24, 1992 to January 12, 1993, The Museum of Modern Art, New York, NY

Matisse *Master of Color*

At age twenty, Henri Matisse discovered a luscious world of color inside a simple box of paints. The pigments were given, by his mother, to preoccupy him as he lay in bed recovering from appendicitis. This innocent diversion soon grew into a passion, which Matisse referred to as his private "paradise." Painting and color experimentation consumed the next six decades of his life and changed the course of art forever.

Matisse (1869-1954) was inspired by the vivid, clashing colors of Vincent van Gogh and Paul Gauguin. Matisse applied his pigments quite differently from his predecessors. Critics couldn't deny the power of his artwork, yet they considered his paintings simple, childlike, and unpolished. Thus, they label Matisse and his followers as *les fauves*, the wild beasts. Despite criticism, the fauvist carried on, concentrating on intense, pure colors that were neither shaded with black nor muddied by other hues. Though fauvism was short-lived, Matisse throughout his long life never ceased connecting colors in imaginative ways and inventing new color combinations. This collage of painted cut-out shapes was created when Matisse was over eighty years old.

Today Matisse is an inspiration for artists of all kinds. Though his talent was unique, the color principles behind his art can be applied by anyone. It's simply a matter of picking up a paintbrush, or using a computer, and getting started.

BOURGES MASTER CHART

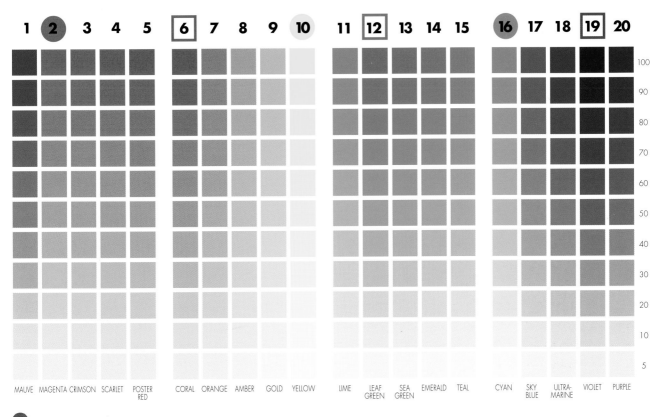

1	2	3	4	5	6	7	8	9	10	11	12	13	14	15	16	17	18	19	20	

Tint values: 100, 90, 80, 70, 60, 50, 40, 30, 20, 10, 5

MAUVE · MAGENTA · CRIMSON · SCARLET · POSTER RED · CORAL · ORANGE · AMBER · GOLD · YELLOW · LIME · LEAF GREEN · SEA GREEN · EMERALD · TEAL · CYAN · SKY BLUE · ULTRAMARINE · VIOLET · PURPLE

⬤ Primary Process Colors

☐ Check-control Colors, combinations of two primaries

Spectrum of Visible Light

GretagMacbeth ©

Note that light is usually shown with the blues first and ending with the reds, because blues have the shortest wavelengths (nanometers). Art charts traditionally show the colors reversed, starting with the reds and ending with the blues. The color sequence stays the same for both.

Artist's Colors for the Digital Rainbow

In between the colors of a painter's palette and the scientist's spectrum of light, there is now a new Bourges color order base. Created in artists' terms and positioned within a digital data exchange, it is designed to be used and understood by students and professionals in both the art and technical worlds.

The rainbow of the artist is shown above as a simple two-dimensional map that defines the parameters of printable color space. It is like a mosaic, with the reds on the left, the blues on the right, and yellow in the middle. This full range of familiar colors is arranged in four basic groups that mirror the spectrum of visible light. All of these 20 colors and tints are produced with combinations of just three process printing inks.

The colors are the first dimension; they are the pure bright hues of the fauvist artist. A full spectrum, with each color visually different from the others, starts at the left with *mauve* and ends at the right with *purple*. Tints are the second dimension shown with the 100% values at the top and reducing to the pale 5% tints.

Taste the Colors with your Eyes

Do you want a bland familiar meal or something hot and spicy? The ingredients are often the same. It is the seasonings that make the difference between a simple stew, a creole gumbo, or a fiery Indian curry. Depending on the skills of the chef, the result can be merely acceptable or a gastronomic delight. And so it is with color, using all types of colorants as well as computer files.

With the same art and text, the use of color can transform a page, creating joy, a sense of authority, or a feeling of comfort. Colors transmit feelings beyond other imagery and can either make the information clearer or muddy the message. This book is full of simple guidelines about using color more effectively.

Get to know the 20 Bourges Profile Colors well, shown throughout the book in italics. Observe how they work individually and together; then move on to explore their tints, shades, and subtle blends.

Printable Color Match

The original source of all the Bourges colors is printing ink, which guarantees that the hues can be accurately matched for reproduction. In this book, only CMY, *cyan*, *magenta*, and *yellow*, the three individual colors used in process printing, are classified as full-gamut colors. They alone are single hues and shown at their maximum brightness. The other hues are blends of these process colors, which slightly dilutes their visual appearance.

However in painting and applications not bound by the limitations of four-color process printing, the gamut or range of the other colors can be extended with the colormetric measurements and different pigments, to create the brighter oranges, cleaner greens, and richer purples.

Calibrated Tint Values

Bourges tints are determined by the halftone dot structure of graphic arts. In this way, the full-strength color is reduced in increments that do not change the appearance of the hue. Rather, the colors appear lighter because there is less ink, revealing more white paper. These tonal scales are easy to match with any form of screened reproduction.

For each color, the master chart shows the full-strength hue and just ten tint values. There are many more, but these are sufficient to visualize and identify the differences in hues. In-between tints can be easily extrapolated from the CMY codes *(see Pages 134-135 and 143).*

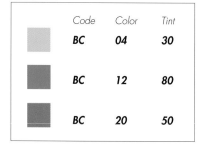

CLIENT Tastemaker ©
ART DIRECTOR Jacqueline Ghosin
ILLUSTRATOR André Francois

Write the Colors

Start with the letters BC to identify the code in the patented Bourges System. Then add the 2-digit number to identify the color, followed by another 2-digit number for the tint value. (If black is added it will be the third set of numbers).

	Code	Color	Tint
	BC	**04**	**30**
	BC	**12**	**80**
	BC	**20**	**50**

How Color Speaks

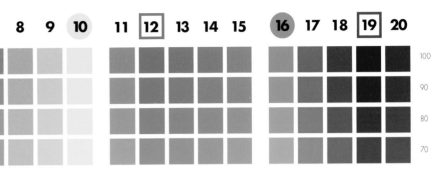
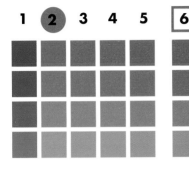

Loud, Bold, Strong

These colors shout. All these colors make a big impact. Used on billboards, commercials, advertising, and posters, they send messages loud and fast. Most people begin their color thinking here, where color is at its purest. Even though the visual differences may be slight, subtle gradations help printers create blends and adjust the amounts of ink needed for multicolor printing.

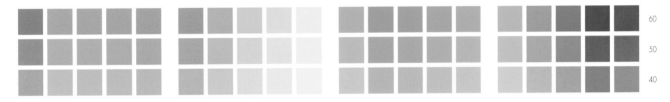

Basic Middle Tones

These colors speak in normal, conversational tones. Midrange colors work well for everyday use. After you've chosen your full-strength colors, these middle tones are the next place to look. These hues convey the same feelings as strong colors but are less intense. Try to develop a mental image of the 50% value, fixing it in your memory, so as to explore both the stronger and paler values.

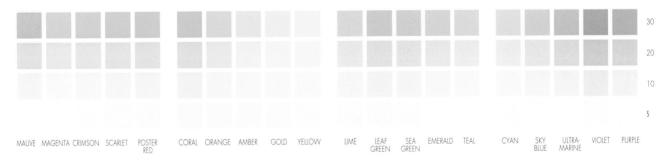

MAUVE MAGENTA CRIMSON SCARLET POSTER RED CORAL ORANGE AMBER GOLD YELLOW LIME LEAF GREEN SEA GREEN EMERALD TEAL CYAN SKY BLUE ULTRA-MARINE VIOLET PURPLE

Soft, Gentle, Pastel

These colors whisper. Because life's most important communiqués are said in low voice, you often tend to give your full attention to a soft-spoken messenger. Who would miss the first murmured "I love you"? In any spoken language, a whisper can be very effective. Though the palest tints may be difficult to see alone, they are essential to any artist's palette.

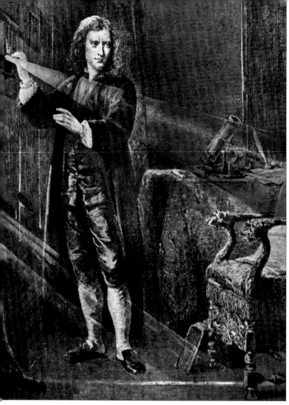

Courtesy of the Collection of Dr. Louis Walton Sipley

Sir Isaac Newton is shown experimenting with a prism in a darkened room, creating the color spectrum from a small beam of light. Since he was able to do this repeatedly, with the colors in the same sequence, he knew this could be studied. Color was the window through which Newton explored gravity, that mysterious force he discovered watching an apple fall from a tree. His interest was not related to the arts but rather to a new kind of learning. . . called science.

COLOR
Where Art and Science Meet

The ancients must have looked upon brilliant hues arcing across the sky as pure wizardry. Science was not around to explain rainbows and why the hue order was always the same. In fact, all color was thought to be a sign of the spirits. Aristotle (384-322 B.C.), one of the first to search for more learned answers, conjectured that colors were derived from mixtures of white and black and emanated from the objects themselves.

Color Becomes a Science

This theory stood unchallenged until 1666, when Sir Isaac Newton (1642-1727) proved that color was the *light* itself and that the colors we see are actually *reflected* light.* Thus color became a formal science, but this didn't stop Newton from studying color's metaphysical nature too. Classically schooled, he drew analogies between color and music (*see Page 11*).

Yet the art community so strongly opposed Newton's scientific laws that it dismissed him entirely. Leading the opposition was Johann Wolfgang von Goethe (1749-1832), who felt that Newton's color theories were inaccurate and superfluous. Thus, two opposing color theories were formed: science and technology vs. art and feelings.

Meeting of the Minds

In the early nineteenth century, art and science made a brief connection through French chemist Michel Eugene Chevreul (1786-1889). As director of dyes at the French Gobelins tapestry works, he observed that certain threads appeared to change color when woven into a tapestry. After assuring himself that there were no problems with his dyes, he concluded that a phenomenon, which he called "simultaneous contrast," was occurring (*see Page 118*).*

Though Chevreul was scorned by his colleagues, many artists embraced these new color theories wholeheartedly. French impressionist and neoimpressionist painters avidly read Chevreul and applied his theory to their work. They experimented with painting dots, swishes, and swirls, allowing the human eye to blend them. Among those artists were Pissarro, Monet, Cezanne, and Van Gogh.

*See color circles for these individual systems on Page 118.

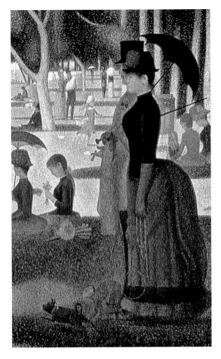

ARTIST Georges Seurat (section of painting)
A Sunday Afternoon on the Island of La Grande Jette, 1884-1886

However, his most devoted disciple was Georges Seurat (1859-1891). Using his pointillist technique, Seurat applied Chevreul's theory with painstaking precision. He systematically placed small dabs of pure pigments to trigger an interplay of color and contrast. From a distance, the colors mingled in the viewer's eye. The most famous example of pointillism is Seurat's painting *Sunday Afternoon on the Island of La Grande Jatte* (1886). By the turn of the century, artists tired of the rigidity of this complex method and moved on to simpler, freer techniques, such as fauvism. More attention was given to the colors than to the exact composition and details of the paintings.

Common Color Language

The first American to attempt to put color into a systematic order was Nicholas Ogden Rood (1831-1902). A professor of science at Columbia University, he identified colors by both light and pigment, and his book *Modern Chromatics* was published in 1897. Albert H. Munsell (1858-1921), a Boston art professor and a contemporary of Rood, went into more detail, using a three-dimensional system of hue, value, and chroma in his 1905 Color Notation System. In 1915, he published a full-color atlas, with hand-painted swatches of all the colors.*

Coinciding with Munsell's efforts were those of Friedrich W. Ostwald (1853-1932), a German chemist and 1909 Nobel prize laureate. After turning his studies to color, Ostwald developed a system that defined hues by even more precise measurements. He based his work on that of physiologist Ewald Hering (1834-1918), whose theories explored how colors were transmitted from the eye to the brain.* Ostwald's system and textbook, *Farbentafeln* (1934), became very popular in Europe and were integrated into the Bauhaus teachings.*

In Louis Walton Sipley's 1951 book, *Half Century of Color*, Albert Bourges (1878-1955) was considered an early pioneer laying the foundation for today's color technology. He was interested in color as print on paper and in the advancement of the CMYK printing process. In 1918, he published his "Bourges Color Notation System" to communicate color information between agencies and engravers.*

Color Goes Digital

At the close of the twentieth century, the computer has taken over the world of color imaging. Today's graphic systems rely on sophisticated instrumentation with densitometers, colorimeters, and spectrophotometers to scientifically measure the light reflected from a controlled source. Then after the artist has chosen a color, it is "read" and given a number that is incorporated into a variety of digital software. Color standards are now in place for art and science to meet again, with a new digital Bourges Color System.

Dr. Louis Walton Sipley
Courtesy of Alice Sipley

*See color circles for these individual systems on Page 118.

Communicating Color Match Data

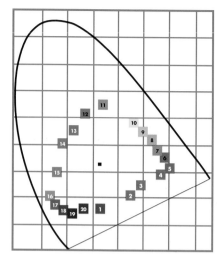

1

CIE 1931 CHROMATICITY DIAGRAM

Here the Bourges colors are shown in xyz values, within a horseshoe shape. A base line connects both ends of the spectrum.

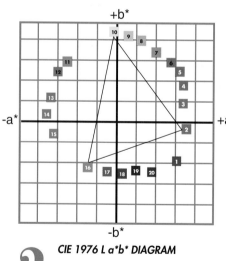

2

CIE 1976 L a*b* DIAGRAM

The same 20 colors plotted in a circular shape, which resembles the familiar artist's color circle (see Page 118).

Electronic technology enables us to scientifically measure and numerically define all colors. This is vastly superior to subjectively describing colors by what one sees, or thinks one sees. Each person responds differently to color, and this response is influenced by many factors, including lighting, surface, memory, age, and even fatigue. Trying to match colors in a purely visual manner is problematic because there are too many variables, such as viewing conditions and quality of the samples.

Digital Color Management

The ideal way to match colors is through a constant, logical numerical system that works today as well as it will tomorrow. The base of such a system was devised in 1931 by the Commission Internationale de L'Eclairage (International System on Illumination), commonly known by its acronym CIE.

This system measures each hue under specific light as seen by a standard observer. The color is given three numbers in X, Y, and Z terms, which are the color's tristimulus (triangulation measurement) values. CIE developed a chromaticity diagram that shows a hue's dominant wavelength and saturation or density. This literally bends the spectrum into the the horseshoe-shaped chart, shown at left, with a straight line connecting the blue and red ends of color space.

The colors that are the purest and strongest are at the edge of the diagram. A black square in the middle, slightly off-center, indicates pure white or the absence of color. Notice that all the Bourges colors are positioned similarly near the edge of the periphery of the horseshoe.

CIELAB Is Established

In 1958, Richard Hunter corrected the visual distortions of CIE. Then a new approach was developed known as CIE 1976 (L a*b*) or CIELAB, which describes a hue by its lightness (L*) and red/green (a*) or yellow/blue (b*) attributes. The roots of this structure go back to Hering, who fathered the "opposing color" theory in science. His approach states that there are four fundamental colors: red, yellow, green, and blue. The mind sees colors through two color receptors, red/green and yellow/blue, plus a third receptor for black and white.

With pure white at the center of this square, the complementary colors are positioned opposite each other, which is the way the artist has been taught to identify these colors. For more information on complements, see Chapter 5.

Wavelength (nanometers)

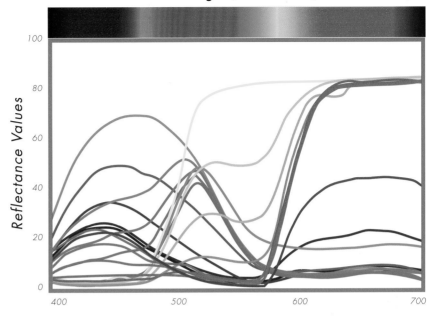

3 **CIE 1964 COLOR CURVES**

More information about a color is obtained by measuring light at many different points across the spectrum; these are at 10° standard observer. This results in a precise linear curve that makes it easy to visually identify and compare with other colors (see Page 146).

THE PAPER FACTOR

The white paper, on which your work is printed is the 5th color. It influences the light reflected and determines the color that is seen. Before printing this book, commercial papers were carefully studied. A #1 grade matte coated paper was chosen for its quality, uniformity, smooth surface, and brightness. A gloss varnish has been printed over only the art images but not on the charts, to preserve their true color match.

Tracking Color Curves

Matching a color often requires more than just measuring it. Sometimes the desired color needs to be compared with another color sample, such as an original swatch. Spectral curves track the reflected colors' wavelengths at regular intervals across the spectrum and place this information onto a graph, where the differences between them can be compared. Spectral curves are used for both pigments and light. Be aware that the two curves will be dramatically different.

Notice how the sequence of colors on the chart above differs from the Bourges chart. The light spectrum starts with blues on the left and ends with reds on the right. This is the way that scientists see colors. Artists see them in reverse order, which is why the Bourges System begins with reds and ends with blues.

Looking to the Future

So what does this mean to you? If you specify your colors precisely, will the printer be able to match them? Yes, this technology exists. The manufacturers of inks, papers, and equipment are now seeking certification from the International Standards Organization (ISO-9000) for quality production standards. What this means to the artist is that now the opportunity exists to choose the exact colors you want and know that the technology is available to match it in the print reproduction, not by another person's interpretation, but by the number codes you click into the computer.

NOTE: In Chapter 2, Pages 32-70, the three color diagrams are shown on on each profile page, identified by the same numbers 1, 2, and 3. This will visually show you how each of the 20 profile colors are translated by the most important colorimetric measurements.

CHOOSE ONE

*Start a color scheme
by selecting one
color as the
theme hue.
Then let
everything else
be supportive.
Make this
key color create
the mood &
set the stage for
the message.*

1 MAUVE

VIOLET RED

This Rainbow Starts Here

BCOI
Cyan 30%
Magenta 100%
Yellow 0%

In 1856, color made a giant step forward when the first synthetic dye was discovered, for until then, clothing colors were limited to only a few stable dyes. This occurred when William Henry Perkin, a college student, was attempting to synthesize quinine from coal tar in his makeshift home laboratory. To his surprise, when he added alcohol, the sludge turned a beautiful violet red. Perkin tested his formula on a piece of silk and found it to be colorfast and fade resistant. At eighteen years old, Perkin patented his synthetic aniline dye and began the manufacturing with his father. Soon thousands of bright, permanent, washable colors were available, including Perkin's violet. Queen Victoria popularized this color by wearing it during the long mourning period for Prince Albert. Though this color was a British discovery, today its known by the French name for the mallow flower, *mauve*.

Position – Leading this group of reds is a mixture of 100% *magenta* and 30% *cyan*. It's the only one of the process reds that contains *cyan* (blue), which connects it to the last color at the end of this spectrum. *Mauve* still has the power of a red but is well-behaved and its passion is under control. Sir Isaac Newton added a purple to join the ends of the rainbow. This violet red at the beginning makes an even better connection to the end of the spectrum.

■ *Mauve* – Related hue, *coral* (6). Opposing hue, *lime* (11).

Psychology – ***Bold Stylish Worldly Impressive Somber***
Sophisticated, *mauve* is not an everyday red. It is a city color, not provincial. Suave, cultured, and classic are qualities that make this a favorite among both fashion and interior designers. This color is similar to the fashion colors of plum and fuchsia.

Using Mauve – Broaden your palette by adding *mauve* as a basic color. Try using it in place of one of the more popular reds. You will not only be pleased at how this underused color holds its own, but by the intriguing mixtures that occur when *mauve* is blended with other hues.

William Henry Perkin, Pioneer in Synthetic Organic Dyes
ARTIST Jerry Allison
Courtesy of Chemical Heritage Foundation, Philadelphia

Three different types of measurement for color refer to charts on Pages 28-29.

1

2

3

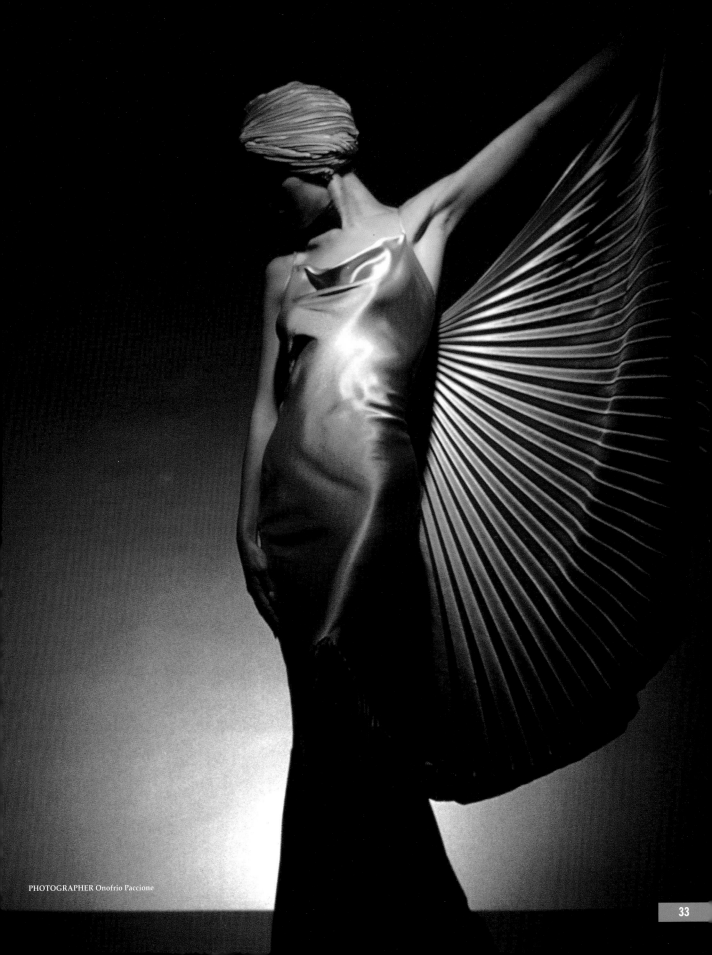

2 Magenta

PROCESS RED

Red Is the Heart of the Art

 BC02

Cyan 0%
Magenta 100%
Yellow 0%

Some colors are named for chemists. Some are named for their pigments. Still others are named for flowers. But *magenta…* this coal tar derivative, redder and brighter than *mauve,* was named for a French military victory. The color was discovered by the French in 1859. In June of that year, the Austrians were defeated by Napoleon III in a small Italian town, just west of Milan. To celebrate, the French christened their new color discovery *"magenta,"* the name of the city in which their victory was won. *Magenta* became an even more popular color, surpassing *mauve,* and was a favorite of the French *noblesse.*

Position – *Magenta* is called the printer's red, as compared to the artist's reds, which are the warmer hues that follow. This color was never a part of the painter's palette, but it is included here because it has always been an essential of color printing. *Magenta* is the "M" of the CMY process colors. There is no *cyan* or *yellow* in this red as shown here. It was chosen because *magenta* combines with the other process hues to give the best gamut of other color combinations.

▪ *Magenta* – Related hue, *orange* (7). Opposing hue, *leaf green* (12).

Psychology – *Romantic Enchanting Sensitive Optimistic*
A lovely, sentimental color, *magenta* offers us pure emotion that abandons all logic and practical thinking. *Magenta* is not an intellectual color and would be considered a poor choice in conveying technical information. Slightly shocking, and sexy rather than practical, it's great for costumes, theatrical decor, and avant-garde fashions.

Using Magenta – This prime hue of the process colors is worth careful study. Learn to use *magenta* well and you will be rewarded. Use this page as your visual reference and check the permanence. Because this is one of the more expensive pigments, some people save money by using cheaper pigments. The result is a weaker hue that detracts from the overall quality. Keep *magenta* clean, pure, and strong for good results. It is the red with a heart.

CLIENT New Jersey State Council on the Arts
Department of State©
DESIGN Cook and Shanosky Associates, Inc.

Three different types of measurement for color
refer to charts on Pages 28-29.

 1 2 3

From the Collection of Thomas L. Cathey
Courtesy of Schurman Designs

3 CRIMSON

C A R M I N E

Red Gets Power from Yellow

BC03

Cyan 0%
Magenta 100%
Yellow 20%

Peering into the etching room of my father's engraving shop, back in the 1920s, was a bit like peeking through the gates of hell. Inside, everything was hot and *crimson*. Metals clanged, gas jets burned, and red dust clouded the room, settling on everything, including the people. This pervasive powder was called dragon's blood. It was a resist melted onto metal plates to protect the dot images during etching. Dragon's blood and the hellish atmosphere of that room are my images of *crimson*. The word itself comes from kermes, a scaled insect that was used to produce a ruby red dye. Later the dye source became cochineal, from a tiny red insect that feeds on cactus. In future years, *crimson* was made from a natural dye, alizarin, and synthesized in 1869.

Position – *Crimson* is a middle red, and the first of the reds to be mixed with *yellow*. When *yellow* is added to pure *magenta,* this red changes and becomes a warmer, more aggressive hue popular with artists and printers alike. With just a small amount of *yellow, crimson* becomes a visually different red but not so bright as *scarlet,* which has more *yellow.*
3 *Crimson* – Related hue, *amber* (8). Opposing hue, *sea green* (13).

Psychology – *Powerful Aggressive Dynamic Dramatic*
Crimson red contains a strong, personal message. That's why a single *crimson* rose represents passionate love, not friendship. Not a gentle color, like *magenta's* "heart," *crimson* demands attention, sometimes in a more threatening than friendly manner. It is the color of war, battles, bravery, action, valor, and bloodshed. It shouts, "Don't argue! Do what I want…now!"

Using Crimson – Lush, plush, grand, and opulent, crimson is more fitting in luxurious commercial settings than in the traditional home. This color has a take-charge attitude that directs the viewer to the message. A little *crimson* goes a long way, so use it wisely. In the lighter tints, *crimson* loses its power and conveys a softer, gentler mood.

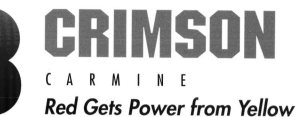

CLIENT Daler Rowney USA ©
GEN. MGR. Anthony Moss

Three different types of measurement for color refer to charts on Pages 28-29.

1

2

3

100%
90
80
70
60
50
40
30
20
10

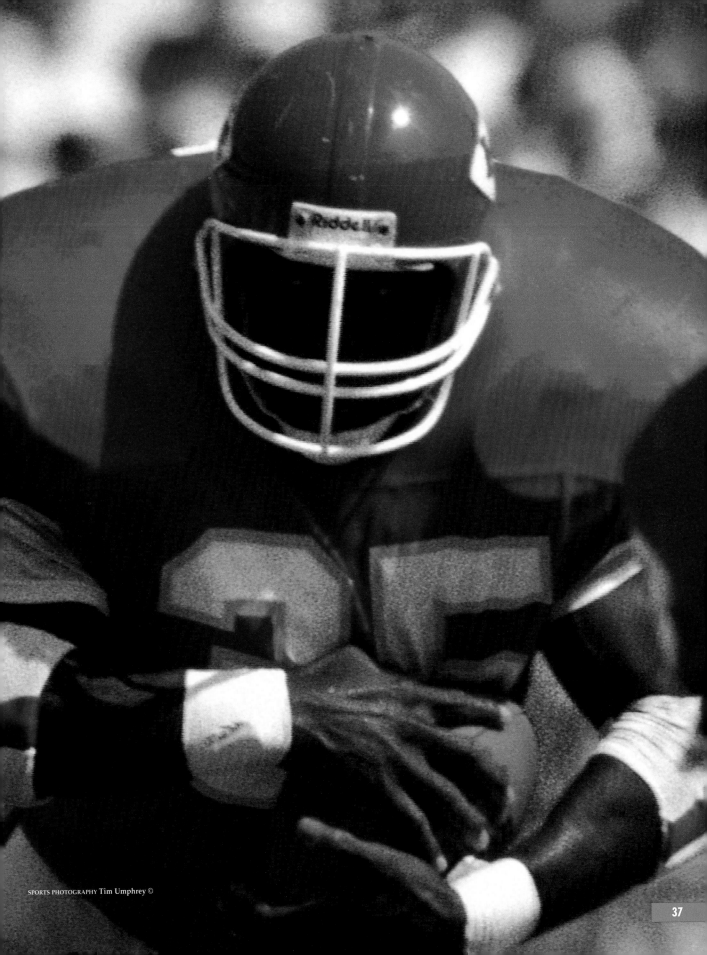

4 Scarlet

APPLE RED

Ripe, Sweet...and Sometimes Naughty

BC04
Cyan 0%
Magenta 100%
Yellow 50%

Red... luscious... tasty. This must have been what primeval humans thought as they viewed the *scarlet* fruits and berries around them. Red drew them to edible foods that were sweet and succulent. Perhaps it's what attracted Eve to the apple and gave this color a naughty reputation. A better name could not have been chosen for the infamous Scarlett O'Hara, who lived her life as if it were dictated by the color. We are attracted to *scarlet*, as if pulled by an unseen magnetism. It is no accident that the color *scarlet* was chosen for the badge of dishonor in Nathaniel Hawthorne's book about Puritan New England. *Scarlet* is associated with brashness, theatrics, bright lights. Think the Big Apple.

Position – *Scarlet*, the fourth red, maintains a delicate balance. Full-strength *magenta* is still the base color, but subtle shifts occur because of an increasing amount of *yellow.* These shifts are most noticeable in the lighter tint values. *Scarlet* has all the power of *crimson,* but the additional *yellow* warms it up, giving it a friendly, outgoing quality.

4 *Scarlet* – Related hue, *gold* (9). Opposing hue, *emerald* (14).

Psychology – *Bright Believable Vivid Positive Effective* *Scarlet* is desirable. It grabs your attention with its intensity and its penchant for drama. At the same time, it has a warm, festive side, reflecting the joy of the holiday season. It is friendly and dependable but more plain than elegant.

Using Scarlet – *Scarlet* is great for spot color, but like any red it can become pushy or irritating if used too much. Overuse reduces its impact. It's best to save bright reds for special occasions, when you need to make a powerful statement. You can get more mileage from *scarlet* by also varying its density and texture on the computer and/or using it in other ways, i.e., with pencil, pen and ink, markers, and paints. Because *scarlet* is so popular, manufacturers of art materials, printing inks, and other colorants offer many excellent matches.

Three different types of measurement for color refer to charts on Pages 28-29.

1

2

3

100%

90

80

70

60

50

40

30

20

10

5 POSTER RED

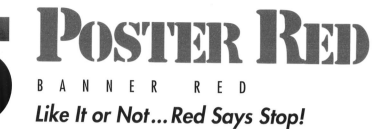

B A N N E R R E D

Like It or Not... Red Says Stop!

BC05

Cyan 0%
Magenta 100%
Yellow 80%

This color reference was distributed to artists and supplied the ink match for 22 Bourges colors from 27 different ink suppliers. These included the popular painter hues as well as the printer's triad of cyan, magenta and yellow.

ART/DESIGN Bob Gill 1955

Drive anywhere in the world and even though you may not understand the language, you know that red means stop! It's almost an involuntary reflex, a reaction that can't be changed by pure whim, as the Communist Chinese discovered. The Red Guard rebellion proposed switching the colors on the traffic lights so that red indicated "go" and green meant "stop." They sought to upgrade red's image, as it was improper for their namesake to carry such a negative connotation. You can imagine the chaos. Drivers would follow their natural instincts, stopping for red when they should have been driving, and driving when they should have been stopping. Red speaks for itself; even in China it says stop.

Position – This is the last of the five reds. *Poster red* is a blend of 100% *magenta* and an almost full-strength *yellow*. In comparing the last three reds to fruits, if *crimson* is a strawberry and *scarlet* an apple, then *poster red* is a tomato.

■ *Poster Red* – Related hue, *yellow* (10). Opposing hue, *teal* (15).

Psychology – *Popular Dangerous Exciting Loud*
At full strength, *poster red* shouts. Like all the other reds, it has a disturbing underlying element. Though the red flares from the battle are exciting, one knows that when the dust settles, there will be casualties. Red warns of impending danger. Red ink can trigger a negative response, like the debt you want to avoid.

Using Poster Red – This is the graphic red and most popular hue for printed matter. Get to know this color well, the 100% and all its tints. Also be sure to check for permanence.

Overview of the Reds – *All of the reds attract attention, charge the emotions, and urge action. The life force of blood that flows through our bodies comes in a variety of reds, making these the most personal of colors and the most important to artists.*

Three different types of measurement for color
refer to charts on Pages 28-29.

1

2

3

CLIENT **Land Rover North America, Inc.**
ART DIRECTOR **Roy Grace**
AGENCY **Grace & Rothschild Advertising** ©

Cyan 0%
Magenta 100%
Yellow 100%

BC06

6 *Coral*

R E D O R A N G E

Bonfire of the Yellows

After the reds, comes *coral,* hot and exciting like a dance of fire that bursts onto the stage throwing out energy in all directions. Lending itself to vibrant scores and fast furious movements, this glorious color is used in costumes, lighting, and staging, to convey these feelings to the audience, seated safely in front of the stage. The flickering flames of a sunset as it blazes across the evening sky are familiar imagery as are the glowing logs of a winter's fireplace. These are good responses, dangerous but under control, and responsible for the light and warmth that make this planet livable. Taking its name from the ancient marine creatures, *coral* has been known for centuries, found in tropical waters wherever pollution has not dulled its bright red-orange color. As careless divers know, color can burn!

Position – This sixth key is the first of the yellows, and it's the first color of this spectrum to contain two 100% process hues, *magenta* and *yellow.* This overprinting is called a check-control color and is an important part of the target graphics in process printing. Though full-strength *coral* looks red, it appears yellower as it tints down.

■ *Coral* – Related hue, *mauve* (1). Opposing hue, *cyan* (16).

Psychology – *Wild Fiery Passionate Glorious Explosive*
Because *coral* looks like a red but acts like a yellow, it seems to have an identity crisis. This color is actually stronger, more intense, and more energetic than the reds. *Coral* is spirited, provocative, untamed, and dangerous. Its out-of-control nature makes it very noticeable.

Using Coral – Fashion calls this key "the new red." It is an excellent color for youth and sports, being bold, vibrant, and powerful. In graphic arts, its brightness contrasts well with black; thus, *coral* works well in two-color printing. Using red-orange pigments, instead of blending process colors, makes it even brighter. Tints of this color, when combined with grays, produce rich, beautiful browns.

Three different types of measurement for color refer to charts on Pages 28-29.

1

2

3

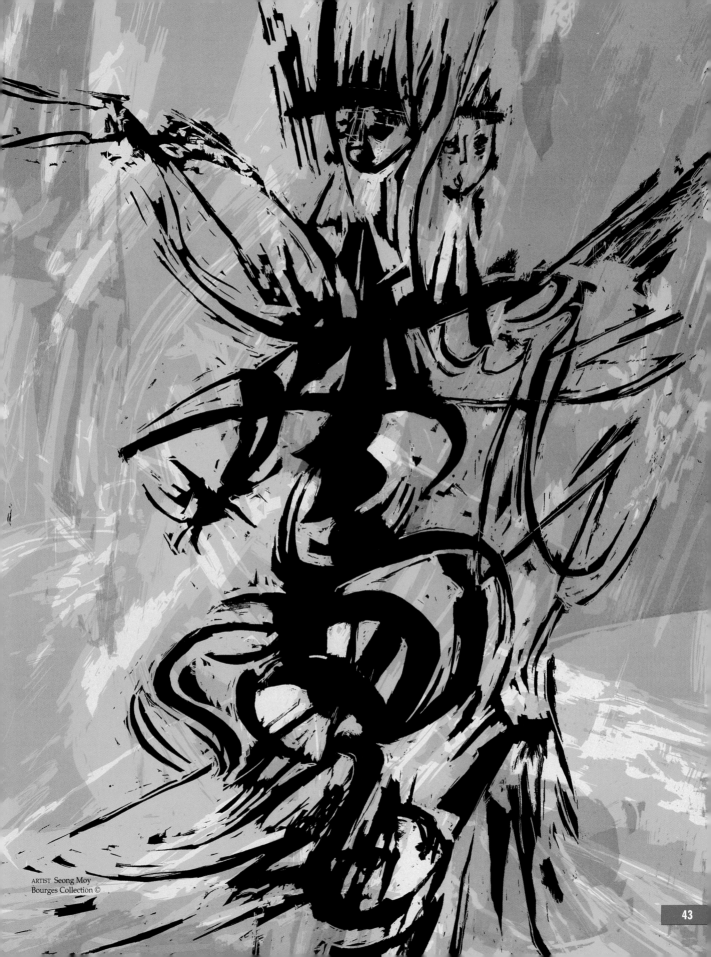

ARTIST Seong Moy
Bourges Collection ©

43

7 Orange

VERMILION
Yellow with a Tang

BC07
Cyan 0%
Magenta 70%
Yellow 100%

Summer makes me drowsy,

Autumn makes me sing,

Winter's pretty lousy,

But I hate spring.

Dorothy Parker, *Ethereal Mildness,*
The New Yorker, March 24, 1928

Frost is on the pumpkin. Copper and bronze leaves clatter in the breeze. It is autumn, that time of year when nature is blazing in regal glory. Fortunately, *orange* isn't restricted to just one season. For many people, a glass of orange juice is as much a part of their everyday morning ritual as a cup of coffee. Oranges are the number-one selling citrus fruit in the world. They have been harvested in southwest China for 4,000 years. Caravans carried them across Persia's silk route to the Mediterranean Sea and on to Europe. Perhaps the first oranges to touch American soil sprouted from seeds brought by Italian explorer Christopher Columbus in 1493. We know orange today by its French name, vermilion, which literally translates as "little worms."

Position – For this seventh color, the second hue in this second group, the base is *yellow. Magenta* diminishes to a support hue. In the familiar artist's palette, *orange* is considered a secondary color, along with green and *purple*, making a familiar color triad.

7 *Orange* – Related hue, *magenta* (2). Opposing hue, *sky blue* (17).

Psychology – *Tangy Tempting Lively Zesty Tart*
Orange's temperament can be likened to the juice, more tart than sweet. Also like the breakfast drink, this color has evolved into a symbol of nutrition, fitness, and strength. It's a warm, cheerful, vibrant, and optimistic color. But for all of its pleasantness, this color warns us also to be cautious. *Orange* is the color of the crossing guards' vests, and it is the color set by international safety standards for hazardous machinery.

Using Orange – A highly visible color that shows up well on either a light or dark background. *Orange* has both visibility and impact, not a comfortable color for fashion or furnishings, but a great choice for fast-food signs. Unfortunately, it is difficult to produce a bright, pure *orange* in process printing. The tonal scale at left, made with CMY hues, is satisfactory; full-gamut colors will be even brighter.

Three different types of measurement for color refer to charts on Pages 28-29.

1 2 3

8 *Amber*

YELLOW ORANGE
Between Orange & Gold

BC08
Cyan 0%
Magenta 40%
Yellow 100%

Courtesy American Museum of Natural History
EXHIBITION "Amber-Window to the Past"
CURATOR Dr. David Grimaldi
PHOTOGRAPHER Jacklyn Beckett

Waves of *amber* grain undulating in the breeze as far as the eyes can see. No symbol could be closer linked to a rich, fertile heartland than this. Every nation's breadbasket is a cornucopia of splendid, earthy delights. *Amber* is the color of prosperity and wealth. The gemstone bearing the same name comes from polished, fossilized tree sap. Particles of prehistoric leaves and insects captured in the resin cause it to sparkle in the sunlight. Saffron, a similar color, is an expensive spice derived from the dried stigmas of purple-flowered crocuses. Buddhist priests of central and eastern Asia wear robes of this color, symbolizing serenity and abundance.

Position – *Amber,* a middle yellow, is not as red as *orange* (7). The base hue for this key is *yellow,* and its support hue, *magenta,* has declined to just 40%. Though a popular warm color, *amber* isn't in many artists' paint boxes, because it's easily mixed from any of the reds and yellows. ■ *Amber* – Related hue, *crimson* (3). Opposing hue, *ultramarine* (18).

Psychology – *Mellow Abundant Fertile Prosperous Contented* Richer than rich, warmer than *gold, amber* is a soothing color to the psyche. Like the middle traffic light, this hue remains neutral, simply warning of an impending change. More commonly, it evokes comfortable imagery: appetizing foods, flowing tankards of beer, cozy fireplaces, an excess of money and *gemütlichkeit* among friends. *Amber* is distinctive. The color of expensive perfumes and cognac, *amber* appeals to the senses of smell, sight, and taste.

Using Amber – This color is visible either by day or night or printed on a light or dark background. It's strong enough to be used as spot color. Even when it's used over large areas, *amber* remains pleasant, never dangerous. That's one of the reasons why it is used in both home furnishings and commercial projects. For warm, cozy effects, try using *amber* in combination with *crimson* or one of the other reds.

Three different types of measurement for color
refer to charts on Pages 28-29.

1

2

3

9 Gold

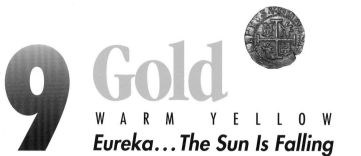

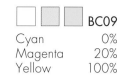
WARM YELLOW
Eureka... The Sun Is Falling

Ancient legends describe *gold* as the son of the sun. Early humans observed this glittering metal in the dirt or at the bottom of a stream, reflecting bright sunlight, and thought it was magical, even supernatural. They surmised that bits of the sun had broken off and had fallen to earth. These fragments were highly treasured and alchemists delighted in the way the polished metal mirrored a wide range of hues, and they dreamed of making fortunes by turning worthless lead into precious gold and so began experimenting. Even though they tried for hundreds of years and didn't find gold, the knowledge they gleaned from these early trials forms the basis of modern chemistry.

PHOTOGRAPHER Douglas Mudd NMAC, NNC
The Smithsonian Institution ©

Position – For this ninth color, or fourth yellow, the base hue of *yellow* is enhanced with just enough *magenta* to distinguish it from *process yellow*. This warm yellow is a favorite among painters. When used as an underbase for other hues, it brings light into their art.

9 *Gold* – Related hue, *scarlet* (4). Opposing hue, *violet* (19).

Psychology – *Joyful Sunny Rich Lavish Uncertain*
Gold is always a warm, lush color. It is buttercups and happy children's faces. Almost in contradiction, it is also a color associated with aging, as in "yellowed" paper. *Gold* is also associated with uncertainty. This comes from an instinctive fear, borne by our ancient forefathers, that the sun might drop over the horizon and never return. Like other sun colors, *gold* can make us anxious. However, its inherent richness makes it an acceptable risk.

Using Gold – Though red attracts attention, humans, like plants, search for sunlight colors, even on a printed page or on a vehicle. A few years ago, this trait gave fire officials an idea. Realizing that red was difficult to see at dusk, they decided to paint all their fire engines yellow. Distinguishable? Easily seen? Not in New York City, where the engines were swallowed up in a sea of yellow cabs.

Three different types of measurement for color refer to charts on Pages 28-29.

1

2

3

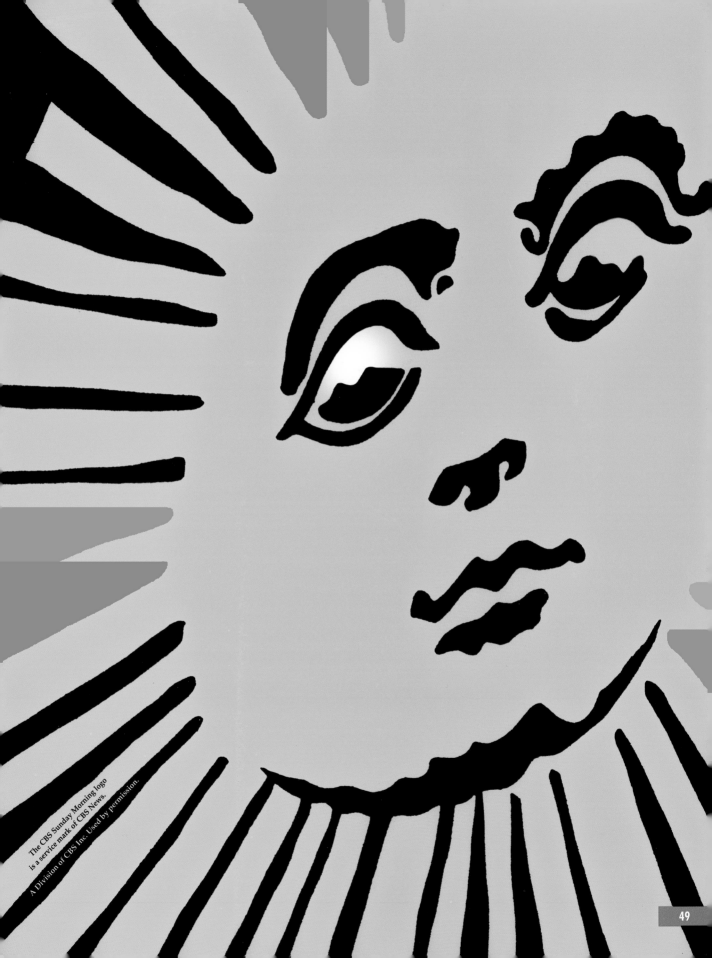

The CBS Sunday Morning logo is a service mark of CBS News. A Division of CBS Inc. Used by permission.

10 YELLOW

P R O C E S S Y E L L O W

Magic Sparks from the Spirit of the Artist

		BC10
	Cyan	0%
	Magenta	0%
	Yellow	100%

The brightest of colors, *yellow* shimmers at the edge of perception. Closest to light itself, it restlessly flickers and then disappears into the twilight. Reappearing, the energy of *yellow* catches our eyes with more force than even white itself. Like genius, *yellow* lightens the darkness with showers of sparks, not just one idea but many that burst out of nowhere, dazzle the eye, and then are gone. Receptor cells in our eyes respond to red, green, blue but none favor *yellow,* yet artists know the magic power of this color and use it aggressively.

Position – This tenth color, the fifth *yellow* and last of the warm chromatics, stands alone, with no *magenta* or *cyan.* As the spectrum's North Star and point of peak brilliance, it is positioned between the warm colors on the left and cool colors on the right. Called printer's *yellow,* it is the "Y" in CMY printing.

■ *Yellow* – Related hue, *poster red* (5). Opposing hue, *purple* (20).

Psychology – *Exciting Inspiring Sour Anxious Sharp* Like biting into a lemon, this *yellow* is startling, more so than any other color. Children like it because it means excitement and adventure. Yet, because it's the first color to disappear at twilight, we are always reminded of its elusive nature.

Using Yellow – While *yellow* is difficult to see alone, other colors are significantly altered when even a pale tint of *yellow* is added. Today in process printing, *yellow* is often printed last, making transparency of the pigment as important as permanence, and this does increase its cost.

Overview of the Yellows *– Fire, excitement, warmth, energy, and imagination are the essence of these hues, making them essential in any artist's palette. The yellows are also associated with the intangible concepts of the realm of "chi," the spirit that harmonizes one's energy and balance with the world.*

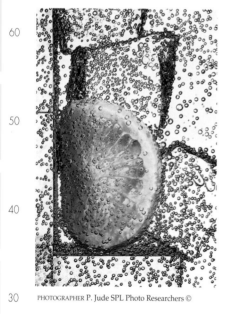

PHOTOGRAPHER P. Jude SPL Photo Researchers ©

Three different types of measurement for color refer to charts on Pages 28-29.

1

2

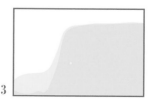

3

"Imagination
is
more
important
than
knowledge."

Albert Einstein

11 LIME

Y E L L O W G R E E N
Out of the Warm… Into the Cool

BC11

Cyan 70%
Magenta 0%
Yellow 100%

A splash of *lime* adds tropical freshness to the artist's palette and it readies the palate for zest. Even before it touches your tongue, the color of *lime* helps you anticipate its cool, tangy flavor. But what if popular gelatin desserts were colorless? Could you distinguish *lime* from cherry? Probably not. In 1945, a test was conducted by Consumers Union with a panel of blindfolded participants. They were asked to taste and identify samples of gelatin. Most could not distinguish the flavors. Imagine the confusion that might result if red raspberry-flavored gelatin were tinted a *lime* green. The eyes, the brain, and the taste buds would be out of sync. Likewise, if a stop sign were painted green, would the driver instinctively stop or go, or be paralyzed by confusion? Such optical illusions can draw attention by surprising viewers; yet, they tend to be more perplexing than beneficial. Color works best when it clarifies and enlightens our pre-existing perceptions.

Position – The first green and the first cool color in the system. A strong, workable yellow green, *lime* is the only Bourges hue in the yellow greens, which are not very popular. It is similar in strength to the other greens, and a better complement to *mauve*. To create additional hues, reduce the *cyan*, allowing more *yellow* to shine through.

Lime – Related hue, *cyan* (16). Opposing hue, *mauve* (1).

Psychology – *Young Fresh Naive Sharp Lively Clean*
Tender, sprouting plants, undeveloped shoots, and new buds are often the fresh yellow green of *lime*. Youthful, fresh, and full of vigor, this is often considered to be a children's color. It is dominated by *yellow's* energy, but *cyan* gives it some control, thinking, and direction.

Using Lime – The brightest of the greens, *lime* is not as sour as a lemon, but it's not sweet either. It's vital to your palette and should be included more often. Try using it instead of *leaf green* to give a more youthful zest to your work.

CLIENT Kraft Foods Inc.
AGENCY Young & Rubicam
ART DIRECTOR Clark Frankel
JELL-O is a Registered Trademark of Kraft Foods Inc.

Three different types of measurement for color refer to charts on Pages 28-29.

1

2

3

PHOTOGRAPHER Carlton Davis for Lacoste

12 Leaf Green

BASIC GREEN

The Color of Life and Money

		BC12
Cyan		100%
Magenta		0%
Yellow		100%

Layers and layers of lush trees, ferns, herbage, moss, and lichen flourish in the rain forest along the Amazon River. Beneath this seemingly calm surface is an alive, busy color. Chlorophyll, the chemical of the green essence in plants, takes sunlight and converts it to life-giving nutrients. Thus, when seeing green, we think growth, progress, or just plain "go," the opposite of red. A green flag starts a car race. A green railroad signal says proceed, the track is clear. In China, jade wishes a new business owner prosperity and success. And, of course, the "greenback" is U.S. tender.

Position – Second in the greens, this hue is also second in the print check-control colors. *Leaf green* is made of 100% *yellow* and 100% *cyan*. Traditionally, artists considered green to be one of the three secondary colors, which also include *orange* and *purple*. However, it holds a prime position in the Bourges System. Neither a fresh, young *lime* nor a sophisticated *sea green*, this is the common, everyday green.
12 *Leaf Green* – Related hue, *sky blue* (17). Opposing hue, *magenta* (2).

Psychology – *Natural Dependable Safe Secure Healthy*
Green is life, the steady breathing rhythm of nature. Nonthreatening and comfortable, this green doesn't pounce on you like the reds nor recede like the blues. It connotes vitality in plants. Yet in humans, looking green indicates illness. Worn by those with self-confidence, this hue is sometimes called "I" or "ego" green.

Using Leaf Green – A bowl of fruit is always a favored choice in decorating, but adding a few green leaves brings this colorful accent to life. Keeping our planet green and keeping nature alive are among our foremost concerns these days. Though we may not have time to actually plant a tree, we can become involved by remembering to add a touch of green to our work. In apparel, this green is not as flattering as some of the bluer hues. As a result, fashions are often made from bluer greens or a tint or shade of this color.

ARTIST Durell Godfrey

Three different types of measurement for color refer to charts on Pages 28-29.

1

2

3

100%

90

80

70

60

50

40

30

20

10

5

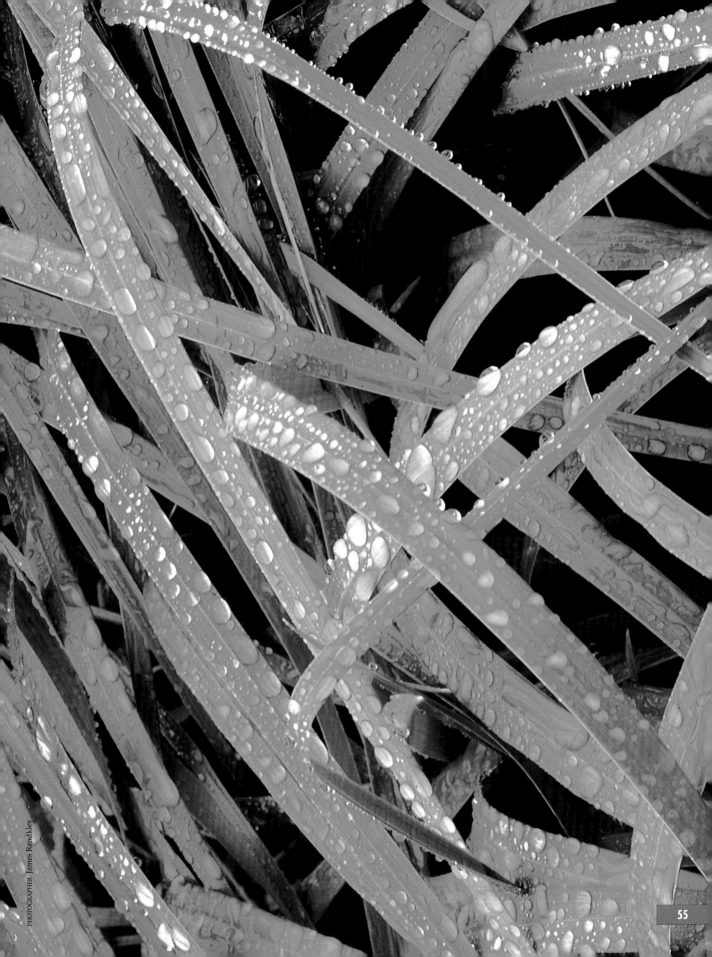

13 Sea Green

BLUE GREEN
Diving into the Depths of Green

BC13

Cyan 100%
Magenta 0%
Yellow 80%

No greater power and strength is known to man than that of the sea. Ancient Romans, being seafaring people who imported much of their food and staples by ship, believed that a mighty god, Neptune, ruled the ocean kingdom. Mythology has it that he caused and prevented great storms at sea; thus, he was ceaselessly worshiped and glorified with valuable gifts. The blue green of the sea is vital to our life cycle. Water is the key distributor of minerals and nutrients through our biosphere. When it evaporates, the water takes with it elements needed in the atmosphere. When it rains, the water seeps into the soil and deposits the nutrients on the roots of the plants. From there, it wanders back to the sea, where the cycle begins all over again.

Position – *Sea green* is the third and middle green. Starting here and going through *violet, cyan* takes over as the base color and *yellow* becomes the support hue. Even though the amount of *yellow* is diminishing here, *sea green* retains a lot of energy. It's a smart green, because its base, *cyan,* is the stronger hue.

■ *Sea Green* – Related hue, *ultramarine* (18). Opposing hue, *crimson* (3).

Psychology – *Mature Strong Urbane Moving Restless*
Sea green is neither a fresh, young sprout, nor a bright, bold leaf. It's bluer, the color of leaves from the evergreens. These mature trees stand tall in densely packed, darkened forests, needing extra chlorophyll in order to absorb more sunlight. Sharp and more sophisticated than common, this color is as wise as Neptune who rules the deep.

Using Sea Green – Containing a base of blue, the tints of this color are clean and distinct. *Sea green* works well on charts and on fine detailed images. It is effective when used over large areas and is easy to match with process colors or individual printing inks, artists' paints, or markers. With red being absent, this color lacks heart. Nevertheless, romance and the sea are as closely entwined as any sailor's knot.

Scanning Electron Micrograph by Dee Breger, Lamont-Doherty Earth Observatory, reprinted from *Journeys in Microspace*, Columbia University Press, 1995

Three different types of measurement for color refer to charts on Pages 28-29.

1 2 3

IMAGE **Benoit B. Mandelbrot**
CLIENT **Richard F. Voss, IBM Research**

14 EMERALD

V I R I D I A N

The Jewel of the Spectrum

If diamonds are a girl's best friend, then perhaps emeralds are her kissing cousin. With a beauty unsurpassed, the emerald is the top-selling colored gem in the world today. Unlike a topaz, ruby, or sapphire, this precious stone has an entirely different demeanor. It appears as soft and smooth as a cut-velvet holiday gown or a freshly manicured lawn. This illusion is created by the refraction of light with minute traces of chromium in the stone. Though emeralds are mined in South America, it is Ireland that is known as the Emerald Isle. The name comes from the island's plush, velvety landscape, and the legendary green-attired inhabitants, known as leprechauns. Irish folklore has it that if you can catch one of these mischievous elves, he will reveal the whereabouts of a hidden treasure.

Position – This fourth green, *emerald* is the smartest and richest of this group. Less of the support hue, *yellow,* is used. *Cyan*, the base color, remains at full strength so this hue appears bluer than *sea green*, but yellower and brighter than the *teal* that follows.
■ *Emerald* – Related hue, *violet* (19). Opposing hue, *scarlet* (4).

Psychology – *Brilliant Beautiful Expensive Wise Eternal*
The emerald, acclaimed for its splendor and value, is also thought to be wise, the most treasured of any attribute. Still, this rare stone has its dark side. Not only is it linked to the green-eyed monster of jealousy, but it is the color of several types of poisons. A most unfortunate example is Paris green, a bright colorant that Parisian decorators painted on palace walls in the late eighteenth century. Fumes from its arsenic content caused many deaths.

Using Emerald – Process *yellow* and blue were used to create *emerald* for this book. However, the phthalocyanine (thalo) pigment in this green shade is an excellent printing match for this color and offers permanence and even greater brightness.

PHOTOGRAPHER Peggy Stockton ©

Three different types of measurement for color refer to charts on Pages 28-29.

 1

 2

 3

The original
emerald crystal,
as it is found
in the earth.

And . . .the ultimate
emerald gemstone,
after it has
been cut and
polished by experts.

15 Teal

TURQUOISE
Soaring Between the Earth and Sky

■	□	□	BC15
Cyan			100%
Magenta			0%
Yellow			20%

Playing an important role in color history, artists of the past beckon to us with *teal*. Limited by the natural pigments that were available, many cultures found this turquoise color and used it in their jewelry, clothes, and ceremonies, particularly to relate to the great birds of the sky. For the Navajo Indians of the West, it was the thunderbird; Central Americans had the condor; and the early Egyptians, the eagle. This may have been the only durable pigment that was at all close to the greens of the trees and blues of the skies, the territory where these great birds soared, delivering messages from the gods.

Position – *Teal* is the fifth and final green. Here, the support hue, *yellow*, diminishes further. Sitting between thalo green on the left and thalo blue on the right, *teal* is often overpowered by its more popular neighbors. In the Bourges System, it's an important separate color, which ends the yellow pigment cycle that began with the color *crimson*.

■ *Teal* – Related hue, *purple* (20). Opposing hue, *poster red* (5).

Psychology – *Primitive Intuitive Ancient Aesthetic Sharp*
Teal brings the outdoors inside. While not as rich as *emerald*, this color is vigorous. It is strong, spiritual, and free like the eagle. Not only is *teal* likeable, but many find it more stimulating than the other greens and more distinctive because it is less widely used.

Using Teal – Almost a blue but not quite, *teal* has just enough *yellow* to keep it a green. It seems to me that there was a time when process blue was close to this peacock hue but no longer. *Cyan* is that color now and the *yellow* is gone. *Teal* is greener and has more life.

Overview of the Greens – *Consider green as a primary color of the palette. Use more greens to put life in your color schemes, not just the popular **leaf green** but all five different hues. Each has a different flavor, by itself or when used in combination with other colors.*

PHOTOGRAPHY Ruddy / Vassilopoulos ©

Three different types of measurement for color refer to charts on Pages 28-29.

1

2

3

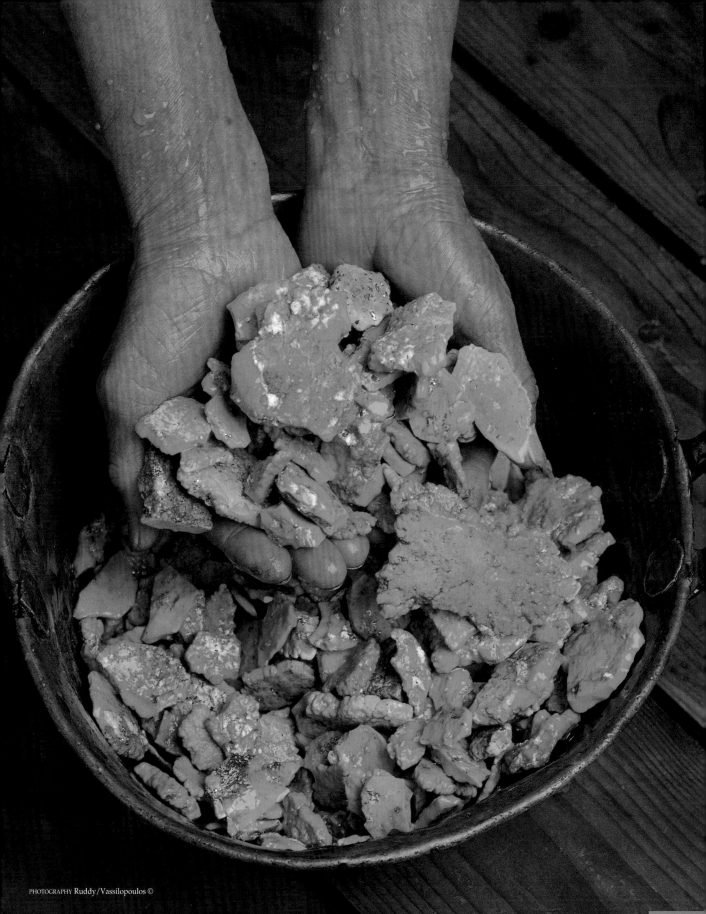

16 CYAN

P R O C E S S B L U E

The Elegant Logic of Cold Hard Facts

			BC16
Cyan			100%
Magenta			0%
Yellow			0%

Winter transforms our familiar world into a cold, mute place. Not only is the sun gone, but red's heart is absent too. Icicles dangle from the eaves, sharp as steel-blue daggers. The north wind howls, rattling the skeletal, ice-crusted trees. There is no sentiment or emotion in this barren landscape. Thus, this blue is the perfect color for diagrams and technical information. Diazzo blueprints are familiar sights in architectural and engineering firms. The sharp blue holds fine detail, which makes it easy to read, analyze, and interpret precision drawings, illustrating the cerebral domain of *cyan,* intelligence and objective information, science, and technology.

Position – Here is the first of the blues. The "C" of CMY process hues, *cyan* is the last of the core colors of this system. While this thalo blue shade is a staple of the graphic arts, it is not the color one thinks of when speaking of blue. Usually one thinks of the warmer *sky blue.*
16 *Cyan* – Related hue, *lime* (11). Opposing hue, *coral* (6).

Psychology – *Sharp Clean Cold Hard Analytical Intelligent*
Lacking warmth from *magenta* or *yellow, cyan* is downright cold. Straight to the point, it presents sharp, clear facts without any distractions. Because this hue is so articulate, many informational signs, such as handicapped parking, are in *cyan.* Artists, who are guided more by their creative spirit, tend to favor the redder, warmer blues.

Using Cyan – Artists call it cerulean. Printers call it peacock. Though some call it green, *cyan* is a true blue – neither *yellow* nor *magenta* is added. Essential to any modern palette, this hue is sometimes considered harsh when used alone. Thus, it is often blended with other colors or used in one of its tints or shades. Paired with *coral,* these two colors make the perfect complements, fire and ice. Each fills in what is missing from the other. *Coral* is full of emotion and energy, while *cyan* is logical and intellectual.

Three different types of measurement for color refer to charts on Pages 28-29.

1

2

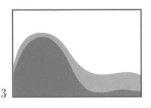

3

100%

90

80

70

60

50

40

30

20

10

Courtesy of Skidmore Owings & Merrill

17 Sky Blue

AZURE

All's Right with the World

			BC17
Cyan			100%
Magenta			30%
Yellow			0%

Whether you're sipping cafe au lait on the sidewalks of Paris, lounging on the beaches of Aruba, or photographing wild animals in the jungles of Kenya, the sky above is the same as it is at home. Even though fog may turn it gray or thunderheads give it a purplish cast, on most beautiful days, the sky is the azure blue seen here. No matter how far you travel, no matter how alien the culture may be, when one gazes at the friendly face of the blue sky above, the world seems better. This is a universal human response and is as embedded in our psyche as our respect for the sun, fear of fire, and longing for the nourishment that keeps us alive. Thus, it's not surprising that blue is the favorite color of most people around the globe.

Position – *Sky blue*, the second blue, contains a touch of *magenta*. With *magenta* as a support, the rawness of *cyan*, the base color, becomes somewhat mellowed. This is a friendlier, more lovable hue. Like the sky, we instinctively embrace this warmer, gentler color. When someone asks for a blue, usually this is the color.

■ *Sky Blue* – Related hue, *leaf green* (12). Opposing hue, *orange* (7).

Psychology – *True Honest Good Calm Clean Peaceful*
Just as *cyan* represents fact and detail-oriented sciences, *sky blue* is identified with philosophy and open-ended ideologies. Never threatening nor aggressive, this blue is symbolic of good will, peace, and tranquility. That's why most people like it. Occasionally, it's thought to be "too good" and a bit dull. Ironically, blue is used to describe risqué jokes and laws governing public morality.

Using Sky Blue – Nearly always a good choice, unless another hue is more suitable, this blue is easy to wear and is as comfortable and unpretentious as a faded-denim work shirt. *Sky blue* is the United Nations color. This organization's pale blue helmets are readily welcomed as a protective force, never an aggressor.

CLIENT Guess Home Collection ©
ART DIRECTOR Paul Marciano

Three different types of measurement for color refer to charts on Pages 28-29.

 1 2 3

ARTIST Steve Hetzel

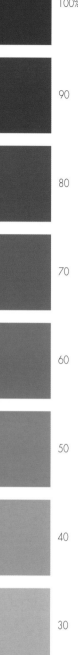

18 Ultramarine
R O Y A L B L U E
A Rich Blue That Sings with Soul

			BC18
Cyan			100%
Magenta			60%
Yellow			0%

Acrylic Paint
Golden Artist Colors ©

Since ancient times, music and color have harmonized in their expression of beauty and emotion. Even the quintessential seventeenth-century scientist Isaac Newton saw a tie between his seven colors and the seven notes of the musical scale. Likewise, *ultramarine* seems to characterize New Orleans jazz. It is the cool, sad strains of a lone jazz saxophone player, whose soulful melodies recount lost memories and future dreams. An old color, this blue was made from crushed, semiprecious lapis lazuli stones. In the Middle Ages, only wealthy art patrons could afford to have their paintings made with this expensive, rich color. Others had to be satisfied with cheaper indigo or copper pigments. Since 1828, this color has been made artificially.

Position – *Ultramarine* is an important middle blue. With a base of *cyan* this hue becomes richer and stronger as its support, *magenta,* increases. *Cyan* keeps this blue under control, but red's sensitivity and compassion tug at its emotions. This blue can be created with process inks, as seen here, but a richer and brighter hue is made with full gamut pigments. **18** *Ultramarine* – Related hue, *sea green* (13). Opposing hue, *amber* (8).

Psychology – *Fabulous Compassionate Stately Moving Soulful* Blue day, blue moon, and blue mood are terms that remind us that this hue can be melancholy. But rather than depressed and down-and-out, this blue is striving, embracing, soulful, and lively. Containing so much heart, its emotions really show. As a frequently used fashion color, *ultramarine* conveys luxury and opulence. Yet it is versatile, working just as well on a magnificent silken wrap as on a simple scarf.

Using Ultramarine – When my father and I began selecting colors for our Bourges color sheets, he wanted to include just the CMY hues, but I found these colors difficult to use. Eventually we compromised and there were two sets of red, yellow, and blue colors, process and a warmer set of artists' poster colors that included this *ultramarine*.

Three different types of measurement for color refer to charts on Pages 28-29.

1

2

3

PORTRAIT Joe Henderson
PHOTOGRAPHER Jack Vartoogian ©

19 Violet

INDIGO
Color's Winter Solstice

Twilight is that fragile moment between dark and light when all *yellow* disappears and a moody, nearly colorless, *violet* diffuses across the sky. In Chicago, after the sun is gone and the temperature drops, a chilly, moist fog swirls in from Lake Michigan. The Windy City is almost as haunting as the British moors. Though this mysterious sight may be briefly tantalizing, we soon long for the friendly sun and clear blue skies to reappear. *Violet* is like a spell of damp, dreary days at the shore. Cool and quiet, only a distant foghorn breaks this surreal setting. Once the sun is gone, we truly miss its warmth and cheerful brilliance. As the old saying goes: "Absence makes the heart grow fonder."

Position – *Violet* is the fourth blue, and the end of the true light spectrum. From here, the rainbow disappears into black ultraviolet. This blue violet contains 100% *cyan* and *magenta* and is the third and last check-control color; the others are *coral* and *leaf green*. Like the winter solstice, this color is the farthest from the sun and has no *yellow* at all. Beginning with the next color, *purple*, the hues start to warm up again and the blues become more emotional.

19 *Violet* – Related hue, *scarlet* (4). Opposing hue, *gold* (9).

Psychology – *Moody Serious Thoughtful Quiet Reflective*
Here control and heart are equally balanced, in complete check. With *yellow* absent, energy and excitement are missing too. Thus, *violet* appears lonely. This hue is indicative of meditative, soul-searching thought. Though low key, power and emotions are at hand. People who like *violet* and its lavender tints tend to be mature, even a bit shy, with deep, soulful intellects that are strong and insightful.

Using Violet – This color is neutral, almost a noncolor, similar to black. Its real color becomes more apparent in its lighter shades. *Violet* is great for lettering and line detail because it is sharp, legible, and sophisticated. It works like a black but is really a color.

Courtesy of Bonwit Teller©
ADVERTISING DIRECTOR Michele Saurman

Three different types of measurement for color refer to charts on Pages 28-29.

1

2

3

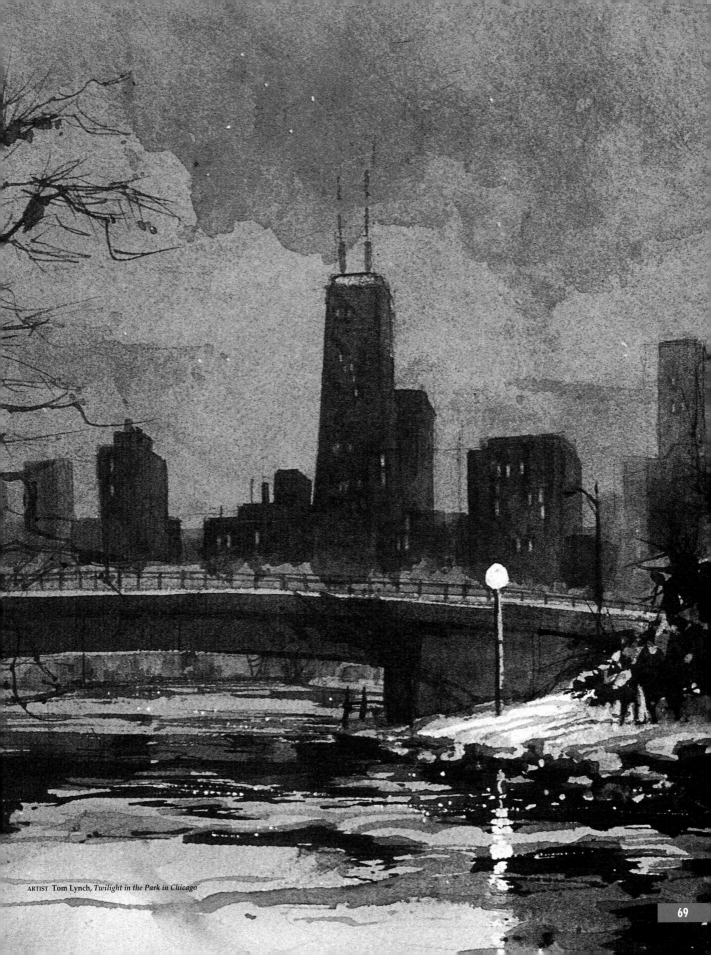

ARTIST **Tom Lynch**, *Twilight in the Park in Chicago*

20 *Purple*

R E D V I O L E T
At the End of the Rainbow...Snails

 BC20
Cyan 70%
Magenta 100%
Yellow 0%

Now that you've reached the end of this rainbow, you'll find not a pot of gold, but...snails. This *purple* pigment was originally created from murex, a tiny shellfish found near Tyre (now Lebanon). Tyrian purple was a strong, rich, and expensive colorant. Historians say that it took approximately 20,000 snails to dye one yard of fabric this color, which for all its beauty, faded quickly. In imperial Rome, *purple* was worn by the nobility. Even today, the monarchy and church leaders wear robes of this hue, which transmit an aura of majesty and authority.

Position – *Purple* ends the blues and concludes this chromatic system. Though *violet* completes the true scientific light spectrum, this red blue visually connects the palette with *mauve* (1). Just as Isaac Newton did, we have visually linked the end with the beginning in order to create a practical color circle. *Magenta* is now the base hue for this blue and *cyan* is its support.

20 *Purple* – Related hue, *teal* (15). Opposing hue, *yellow* (10).

Psychology – *Grand Regal Leader Superior Majestic*
Purple does everything *violet* does but more graciously, with majesty. With the heart in charge, control has relaxed. This hue doesn't have the unfettered passion of the bolder reds that start this palette. It simply provides the suggestion of excitement.

Using Purple – This is a staple of the artist's palette, even though it is not very popular. Manufacturers traditionally produce at least one *purple* towel each year. While this towel may not be the retailers' best seller, they find a steady demand for this royal indulgence.

Overview of the Blues – *The most common-sense, practical hues of the spectrum begin with cyan, the color of science and high technology, and go through purple, the grand sovereign. You just can't argue with these colors. They are too logical, too reasonable, and too fair. They seldom evoke negative responses.*

Henri Matisse, *Snails*
1997 Succession H. Matisse Paris/
Artists Rights Society (ARS) New York ©

Three different types of measurement for color
refer to charts on Pages 28-29.

1 2 3

BLACK IS THE 3RD DIMENSION

Adding black/gray
to any color adds
depth & dimension.
It is always there
in process printing,
ready to create
thousands of
different shades
from the 20 colors
& tints of the rainbow.

BOURGES MASTER CHART

1	2	3	4	5	6	7	8	9	10	11	12	13	14	15	16	17	18	19	20	

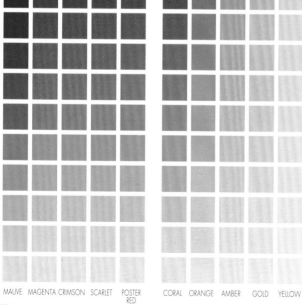
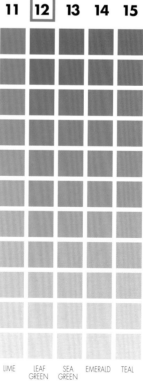
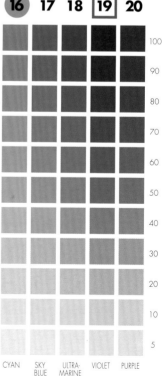

| 100 |
| 90 |
| 80 |
| 70 |
| 60 |
| 50 |
| 40 |
| 30 |
| 20 |
| 10 |
| 5 |

MAUVE MAGENTA CRIMSON SCARLET POSTER RED CORAL ORANGE AMBER GOLD YELLOW LIME LEAF GREEN SEA GREEN EMERALD TEAL CYAN SKY BLUE ULTRA-MARINE VIOLET PURPLE

BOURGES MASTER CHART plus 5% Black Tint

1	2	3	4	5	6	7	8	9	10	11	12	13	14	15	16	17	18	19	20	

| 100 |
| 90 |
| 80 |
| 70 |
| 60 |
| 50 |
| 40 |
| 30 |
| 20 |
| 10 |
| 5 |

MAUVE MAGENTA CRIMSON SCARLET POSTER RED CORAL ORANGE AMBER GOLD YELLOW LIME LEAF GREEN SEA GREEN EMERALD TEAL CYAN SKY BLUE ULTRA-MARINE VIOLET PURPLE

COLOR BYTES

BOURGES MASTER CHART plus 10% Black Tint

1	2	3	4	5	6	7	8	9	10	11	12	13	14	15	16	17	18	19	20	
																				100
																				90
																				80
																				70
																				60
																				50
																				40
																				30
																				20
																				10
																				5

MAUVE · MAGENTA · CRIMSON · SCARLET · POSTER RED · CORAL · ORANGE · AMBER · GOLD · YELLOW · LIME · LEAF GREEN · SEA GREEN · EMERALD · TEAL · CYAN · SKY BLUE · ULTRA-MARINE · VIOLET · PURPLE

Grays Create Shades

The concept of light and dark actually precedes color. Primitive words existed for both long before there were words for color. Black and white are truly a primal pair, but since this book is about color, the achromatic hues (black and white) are treated here in their support roles — to add shape, shadow, depth, and detail, and to lighten or darken chromatic hues. Black produces shades of gray; white is the paper.

The only difference between the chart above and the one at left is that a 10% black tint has been surprinted. The colors above appear duller but stronger because of the addition of black. Only a 5% black has been added to the chart at left, but even so, the raw brightness of the master colors has disappeared and the hues are softer, more classic, and often more pleasing to the viewer.

With colors serving as the first dimension and tints as the second, black/grays are the third dimension. Shadows make colors recede. In measurements, grays are also a third factor providing precise information for color match. Black is the "K" of CMYK, derived either from the last letter of the word "black" or from the graphic term "key" plate. Black is an essential part of process printing, creating darker shades, which are an easy, practical way to extend your color palette.

BOURGES MASTER CHART plus 30% Black Tint

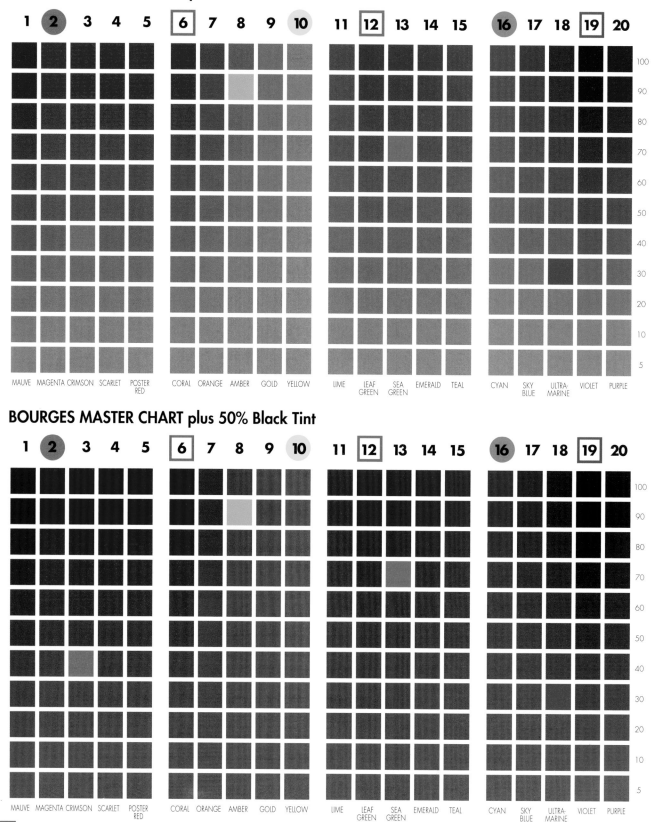

BOURGES MASTER CHART plus 50% Black Tint

BOURGES MASTER CHART plus 70% Black Tint

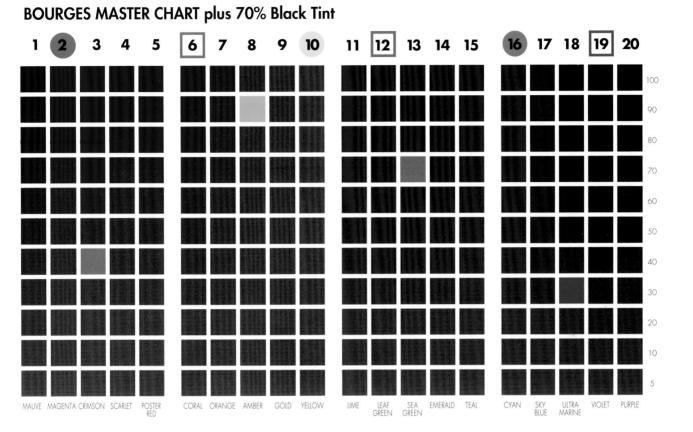

| 1 | 2 | 3 | 4 | 5 | 6 | 7 | 8 | 9 | 10 | 11 | 12 | 13 | 14 | 15 | 16 | 17 | 18 | 19 | 20 |

Column values (right side): 100, 90, 80, 70, 60, 50, 40, 30, 20, 10, 5

MAUVE MAGENTA CRIMSON SCARLET POSTER RED CORAL ORANGE AMBER GOLD YELLOW LIME LEAF GREEN SEA GREEN EMERALD TEAL CYAN SKY BLUE ULTRA-MARINE VIOLET PURPLE

Paul Klee, *Flowering*, 1934, Artists Right Society (ARS) New York/VG Bild-Kunst Bonn

From the innermost circle of Paul Klee's Weimar period comes these color squares. A Bauhaus professor, and famous master of color, this image painted on a flat surface has a magical three-dimensional effect because of the grays.

Black Makes Colors Brighter

Navy, mustard, burgundy, sage, and taupe are just a few of the popular fashion shades that you will find in these charts, produced by simply adding grays to the colors on the Bourges Master Chart. With the addition of just ten gray tints, the original 220 swatches become 2,200 hues and even more, with closer increments.

Most important, grays increase the contrast between colors; when they are used to darken one area, they make another area appear to be brighter. This is modern chiaroscuro, the term given to this technique by the master painters of the baroque period, with Rembrandt Von Rijn its acknowledged master.

On the three color charts surprinted with 30%, 50%, and 70% black, the four pure chromatic swatches enable you to see the increasing contrasts; as the gray increases, the pure colors appear brighter.

"Flowering" by Paul Klee, at left, is a perfect example of a more modern use of this heightened contrast. He was an expressionist painter, part of a group of creative artists in Germany that started in 1905, the same time as the fauvists in France. Both loved color, but the expressionists favored more abstract design elements than the simple, natural scenes of the fauvists.

DIGITAL COMPOSITION
Jan Ewoud Vos

Black and One Color

Flat Tint	Duotone	Texture

MAGENTA

2 2 2

SCARLET

4 4 4

CORAL

6 6 6

AMBER

8 8 8

YELLOW

10 10 10

TEXTURE is added to the duotone image to create more interest and detail, #332 stock pattern is supplied by AUTO F/X.

DUOTONE is an image with tonal gradation in both the black and color plate which adds depth and dimension.

FLAT TINT is the simplest way to add color to any black tonal image. The same 30% tint value is used for all images.

Texture
Duotone
Flat Tint

LEAF GREEN

EMERALD

CYAN

ULTRAMARINE

PURPLE

12 12 12

14 14 14

16 16 16

18 18 18

20 20 20

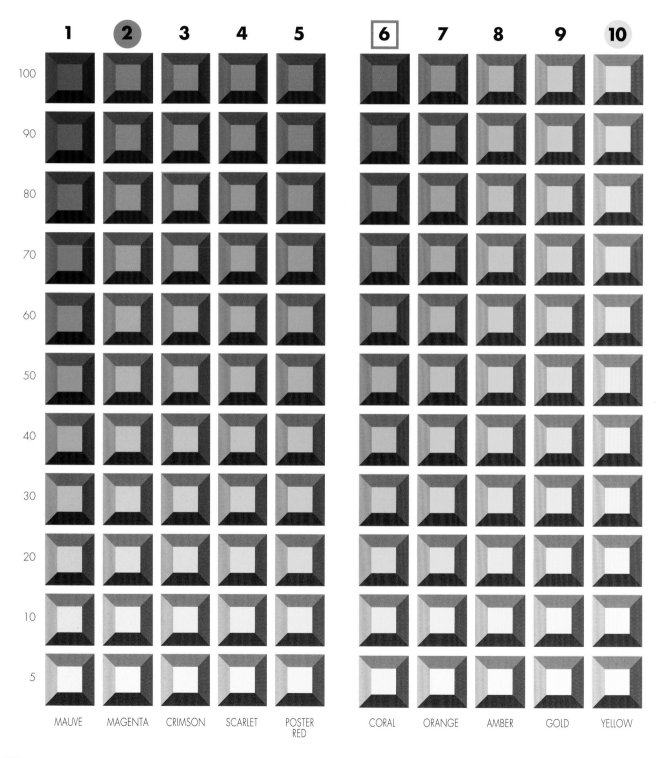

	1	2	3	4	5	6	7	8	9	10
100										
90										
80										
70										
60										
50										
40										
30										
20										
10										
5										

MAUVE · MAGENTA · CRIMSON · SCARLET · POSTER RED · CORAL · ORANGE · AMBER · GOLD · YELLOW

BASIC COLORS

This Bourges Chart is the same as the one on pages 132-133. The only difference is that the four tints of black, shown at right, have been surprinted over the squares of each color and tint.

BLACK TINTS (GRAYS)

These are the four shades of black that have been added. Note how different they look over the 100% colors and the lighter tints; and over the warm colors and the cool hues.

11	**12**	**13**	**14**	**15**		**16**	**17**	**18**	**19**	**20**	
											100
											90
											80
											70
											60
											50
											40
											30
											20
											10
											5
LIME	LEAF GREEN	SEA GREEN	EMERALD	TEAL		CYAN	SKY BLUE	ULTRA-MARINE	VIOLET	PURPLE	

CHAPTER 4

WARM OR COOL

Bourges divides the spectrum into two equal parts. The warm colors are the first half, the right-brain hues, exciting & emotional. The cool colors are the other half, those wise & analytical left-brain hues.

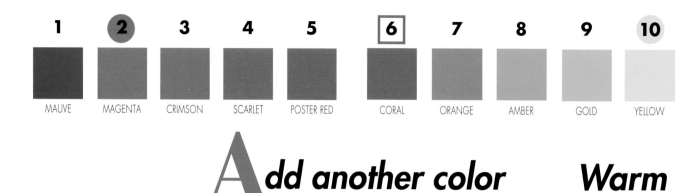

1	2	3	4	5	6	7	8	9	10
MAUVE	MAGENTA	CRIMSON	SCARLET	POSTER RED	CORAL	ORANGE	AMBER	GOLD	YELLOW

Add another color Warm

Now let's start using the 20 colors as building blocks. First select the hue that will be the foundation for your color scheme. Add another as its support. This second hue should enhance the first, giving it dimension and making your overall message more effective.

Unless you are experienced or creatively inspired, choosing the perfect color combination can be tricky. Picking colors at random can be frustrating. This system provides some basic guidelines that help you quickly locate visually pleasing hues. It's easy to try them out, and if they don't work, return to the original format and try again.

When Colors Speak, Mood Talks

There are *two* basic ways that colors work in balanced harmony: *related* hues such as warm and cool, described here, and *complements*, shown in Chapter 5. Some people use the terms warm and cool to compare one color with another or to talk about color positions in the artist's spectrum, using such terms as warmer reds and cooler blues. In the Bourges System each color is clearly defined as warm or cool.

Bourges Divides the Rainbow

The spectrum at the top of these pages breaks into two parts at its point of peak brilliance, the lone pure process *yellow* (10). The warm colors, reds and yellows, are on the left and the cool colors, greens and blues, are on the right. The five reds all have *magenta* as their prime hue and the yellows have 100% *yellow*. The cool colors begin when *cyan* is added. The five greens are blends of *yellow* and *cyan*, and the blues are blends of *magenta* and *cyan*.

The Bourges rainbow includes an equal number of warm and cool colors. If it were designed strictly according to artists' and designers' usage, it would incorporate more warm than cool colors. By contrast, the scientific light spectrum *(see Page 23)* has more greens and blues and fewer reds and yellows. The Bourges spectrum is a compromise between the two. It contains ten *warm* and ten *cool* colors, a balanced system.

11	12	13	14	15	16	17	18	19	20
LIME	LEAF GREEN	SEA GREEN	EMERALD	TEAL	CYAN	SKY BLUE	ULTRAMARINE	VIOLET	PURPLE

● Primary Process Colors

☐ Check-control Colors, combinations of two primaries

. . . or Cool

Take Five for Related Pairs

The 20 colors above are divided into four groups of five colors each (*see Pages 20-21*). Thus, five becomes an intentional numerical pattern enabling you to easily find a related or support hue. To do so, simply move five steps away from your key color. If that color is in the reds or greens, *add* five to the original number. When it is in the yellows or blues, *subtract* five to get the support hue.

This formula keeps both colors on the same side of the warm-cool spectrum, which assures a similar message. It also places them in the same position of each group. Being five steps apart, the support color is far enough away to be visually very different, yet near enough to be related in mood. While you can team up colors that are closer, the differences between them may be so subtle that they may blend together rather than function as separate hues.

Colors Are the Message

Respecting the divergent messages sent by the opposite sides of the color spectrum, will help you set an active or passive mood in your work. Reds and yellows are symbolic of blood, battle, and bravery. They push, shout, warn, and command attention. On the other hand, cool colors persuade viewers with reasoning, restraint, and wisdom.

Right-Brain vs. Left-Brain Colors

The two halves of the color spectrum can be likened to the workings of the two hemispheres of the brain. The right side operates more creatively, stimulating ideas and imagination, traits also found in vibrant reds and yellows. The left brain is more logical, directing orderly thought, like greens and blues.

Other differences are also apparent. The edges of warm colors tend to blur, while cool hues have crisp, sharp definition. Colors on the warm side of the spectrum seem to reach out and touch us; they are considered to be near-sighted. On the other hand, cool colors recede and tend to disappear. They are said to be far-sighted. Near-sighted colors are good for short, straight-to-the-point impact, while far-sighted hues create beautiful, lasting impressions.

STAMPS became an opportunity for artist's in Finland to display their skills. These stamps are two from the winning set submitted by Paulina Kaleva and Kari Kivinen. 1994-5.

REDSYELLOWS

WARM COLORS COME TOWARD YOU

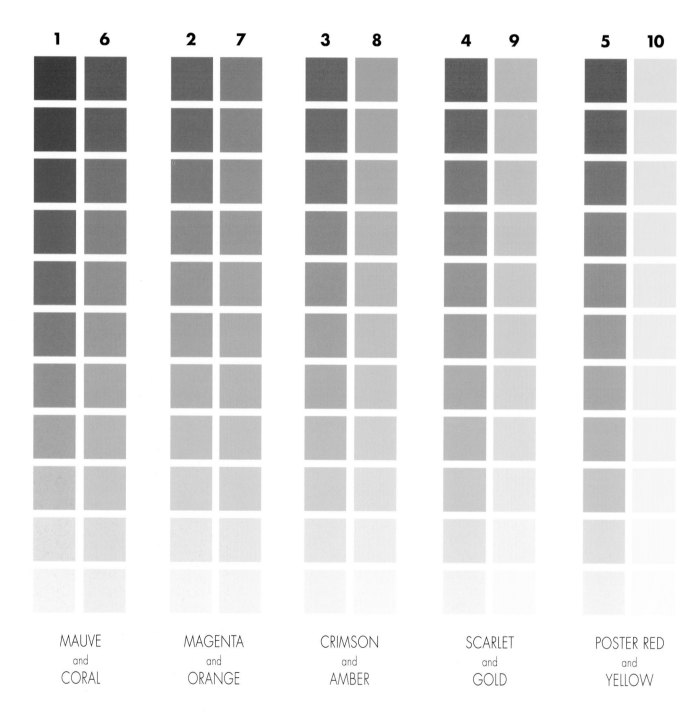

1 **6** **2** **7** **3** **8** **4** **9** **5** **10**

MAUVE
and
CORAL

MAGENTA
and
ORANGE

CRIMSON
and
AMBER

SCARLET
and
GOLD

POSTER RED
and
YELLOW

Warm Colors Excite the Eyes

Sunrises and sunsets are the sun's *tableau vivant*. Filled with reds and yellows and their tints, these natural phenomena excite us physically as well as emotionally. Warm colors work in unison to bring us energy, passion, power, light, and joy. These are the most popular colors that artists use.

Strokes from the Warm Palette

By pairing together colors on the warm half of the spectrum, you can unify and strengthen your message. Take two very bold colors: *magenta* (2) and *orange* (7). These related hues, five steps apart on the chart, are wilder and more vibrant together than they are separately.

Long ago when designer Melanie Kahane introduced this red/orange color combination in the '50s, critics labeled her creations garish and said they would never last. Not so. In fact, they became roaring successes, and this color combination is still used in fashions, commercial furnishings, and advertising. You can achieve a softer, subtler adaptation of this look by using tints of these hues or adding touches of gray to create shades.

Charting the Warm Hues

On the facing page is a chart of 110 colors, ten warm hues plus their tints. Note that the colors are paired together to show five different two-color combinations, simple balanced color schemes that are easy to remember. All convey feelings of power and energy, more forcibly with the deeper values and more gently with the paler tints.

Generally, it's a good idea to use a strong main color and enhance it with a weaker tint. One of the most popular warm color combinations on this chart is *scarlet* (4) and *gold* (9). It's used nearly everywhere in advertising, posters, and packaging for quick attention and great visibility.

Adding the Shades

Adding all the grays increases this palette to 1,100 pure, warm colors. These shades give more depth to the warm color and also create a four-color illusion, with the gray taking the visual place of *cyan* in the color scheme. When gray is mixed with reds and warm yellows, it creates a brown. See Page 142 for more information about the browns.

PHOTOGRAPHER Mark Wayne©
Courtesy Minolta Corporation

PHOTOGRAPHER Dag Sundberg

Courtesy Gucci

PHOTOGRAPHER Simon Metz ©

PHOTOGRAPHER Jim Scherer Graphique de France ©

PHOTOGRAPHER Mark Wayne
COURTESY Minolta Corporation

PHOTOGRAPHER John Bigelow Taylor

©K.Haring

Courtesy LTA Learning to Read Through The Arts, Inc. ©
ARTIST Keith Haring Guggenheim Museum

ARTIST Les Kanturek ©
Professor of Illustration
Parsons School of Design

ARTIST Trudy Kraft

COLOR BYTES

ARTIST/TEACHER John Costanza ©
Winner AARP Contest

PHOTOGRAPHER Timothy Greenfield-Sanders, 1991 ©

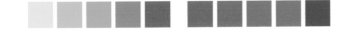

COLOR BYTES

GREENSBLUES

COOL COLORS MOVE AWAY FROM YOU

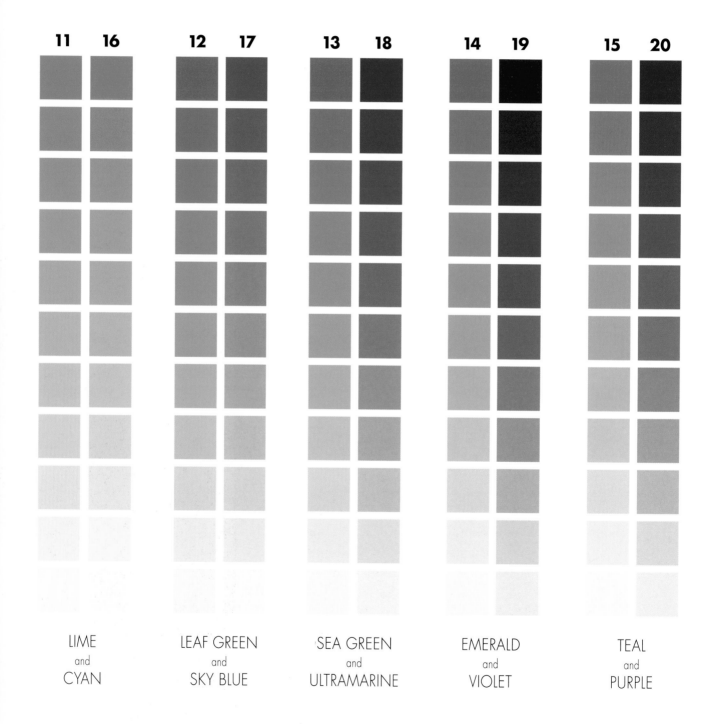

11 16 **12 17** **13 18** **14 19** **15 20**

LIME
and
CYAN

LEAF GREEN
and
SKY BLUE

SEA GREEN
and
ULTRAMARINE

EMERALD
and
VIOLET

TEAL
and
PURPLE

Cool Colors Soothe the Senses

Slow down, take a breather, and rest your eyes. This is the message sent from the cool side of the spectrum, almost sunless. It contains just as many beautiful colors as the warm side, but the mood is completely different.

Capturing the quiet, cool colors of the water lilies floating tranquilly on top of his garden pond in Giverny was a favorite pursuit of Monet's. On this page, his work has influenced this stained glass window. Though this work is sharper, crisper, and more abstract than Monet's paintings, it captures a fresh, peaceful, harmonious atmosphere.

Mapping the Cool Colors

The chart on the facing page contains 110 cool colors, ten full-strength hues plus their respective tints grouped together in pairs, five steps apart. Since these colors are naturally duller than warm ones, grays are added less frequently and usually in just the lighter shades. Adding gray to even the palest tints makes a visible difference, adding a subtle sophistication to the pure cool colors.

All of the cool colors, except *lime* (11)and *purple* (20), are made with 100% *cyan*. These two hues have only 70% *cyan*. The greens are combinations of *yellow* and *cyan,* whereas the blues are combinations of *magenta* and *cyan.*

Selecting Cool Pairs

Probably the most popular blue/green combination is *leaf green* (12) and *sky blue* (17). These are the colors most people view as basic green and blue. Separately, these are very popular colors; set side by side, they're an excellent pair.

Personally, my favorite cool color combination is *emerald* (14) and *ultramarine* (18). Though they are only four steps apart, as opposed to the five normally suggested, they still work. It's important to remember that the five-step formula is simply a guide to making color choices, not a hard-and-fast rule.

Sending the Right Message

Even though the cool colors have many variations, it's a good idea occasionally to wake up your viewers by changing the pace. For instance, in a lengthy slide presentation using predominantly cool colors, intersperse a few warm images. Muted combinations will not detract from the overall message but will add interesting variations. Greens and blues are fine when you already have your audience's attention and simply want to make a pleasant factual presentation.

Courtesy Glassmasters, Martha Gibby, President

Louisiana Office of Tourism
Bruce Morgan, Dir.

CLIENT *The New York Times* ARTIST Carl Molno ©

COLOR BYTES

NO PLACE LIKE HOME

Smithsonian

Tiffany "fireworks" Brooch
Tiffany & Co. ©

COLOR BYTES

PHOTOGRAPHER Scott Drickey

OPPOSING COLORS

*Every color
has its mate.
Complements are
any two colors that
when combined,
block out all
reflected light.
Used next to each
other both
become brighter as
described in*
Chevreul's Laws
of Simultaneous
Contrast, 1839.

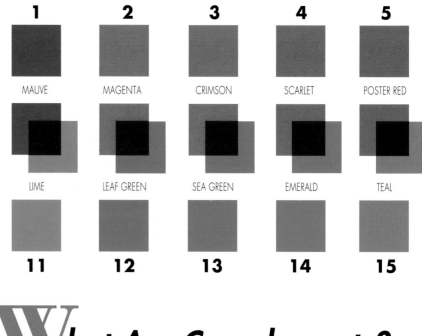

1	2	3	4	5
MAUVE	MAGENTA	CRIMSON	SCARLET	POSTER RED

LIME	LEAF GREEN	SEA GREEN	EMERALD	TEAL
11	12	13	14	15

No black is used to print these squares. They are produced by overprinting two complements, which when added together equal 100% process cyan, 100% process magenta, and 100% process yellow, which effectively blocks out all reflected light.

What Are Complements?

Of all the pairs of colors, complements are the most important because they are the combinations that actually change the appearance of their opposites most noticeably. Complements are best described as exact opposites that enhance one another. What is missing from one color is contained in its mate. When you blend the two together, you get full color saturation, neutral black. As in an eclipse, all reflected color is blocked out so that you see no color at all. Mathematics proves this. When you add up the CMY percentages in a pair of complements, they total 300%: 100% *cyan*, 100% *magenta*, and 100% *yellow*. This is the maximum recommended ink saturation for multicolor printing. See Pages 134, 135 for all these process codes.

Making Colors Brighter

While warm and cool colors have familial relationships, complements are like lovers. They evoke passion and drama in their opposites. Though each is the emotional antithesis of the other, the two colors respond well when brought together. Both appear brighter and more exciting.

Seeing Auras

M.E. Chevreul coined the term "simultaneous contrast" to describe the color dynamics of complements. He determined that each color is surrounded by a contrasting aura that is invisible on a white background but visible over another color. This aura alters the colors around it, particularly when it is the complement, and more so when it surrounds the color.

"A" COMPLEMENTS

Relates to the Red/Green axis of Diagram 2 on Page 28.

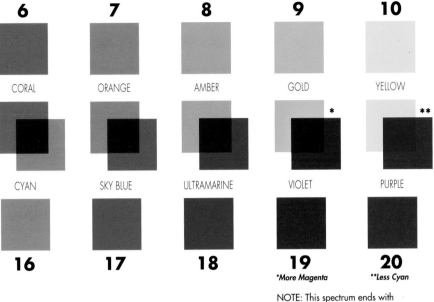

CORAL ORANGE AMBER GOLD YELLOW

*
**

CYAN SKY BLUE ULTRAMARINE VIOLET PURPLE

16 **17** **18** **19** **20**

*More Magenta **Less Cyan

NOTE: This spectrum ends with *purple*, see page 70, which shifts the combinations of these last two sets.

Warm Colors
From mauve to yellow, *the first ten colors of the spectrum. All the warm colors, five reds and five yellows, are shown on this top row.*

Cool Colors
From lime to purple, *the last ten colors of this spectrum. This bottom row consists of all the cool colors, five greens and five blues.*

See for yourself. Stare at a color for several seconds; then shut your eyes. Immediately another color will appear. This is the color's opposite hue or its complement. The French impressionists were fascinated with this theory and manipulated complements to increase contrast and accent specific areas of their paintings.

Start by finding your key color's complement on the chart above. The ten warm colors are stacked above the ten cool colors. This makes ten pairs of calibrated complements. Your complement is located ten steps away from your key color, positioned either directly above or below. If your key color is warm, *add* ten. If your key is cool, *subtract* ten.

Complex Complements

Red/Green - These warm reds and cool greens are the "A" complements and relate to the a* axis of the CIELAB color measurement system (*see Page 28*). All the overprinted black squares in the middle are the result of 100% saturation of the three CMY colors. These pairs are so well balanced and similar in appearance that any red can be used as an opposing color to any green.

Yellow/Blue - These colors are the "B" complements and relate to the b* axis of the CIELAB color measurement (*see Page 28*). In this group, complements must be selected from vertical pairs, oranges with blues, and yellows with purples. Such colors as process *yellow* and *cyan* do not function together as true complements; when blended, these hues create *leaf green*, rather than black.

"B" COMPLEMENTS
Relates to the Yellow/Blue axis of Diagram 2 on Page 28.

REDSGREENS

"A" COMPLEMENTS ARE THE MOST POPULAR

1	11	2	12	3	13	4	14	5	15

MAUVE
and
LIME

MAGENTA
and
LEAF GREEN

CRIMSON
and
SEA GREEN

SCARLET
and
EMERALD

POSTER RED
and
TEAL

The Holiday Complements

This striking pair of red and green evokes celebration, recalling the rich fragrance of pine, the ripeness of berries, and the festivities of the winter solstice, when we choose the most vibrant colors on those darkest days. More than just holiday colors, red and green are the familiar colors of Mother Earth, of flowers, fruit, and foliage. These are the colors that are closest to our psyche.

Because reds and greens are such intense colors, they're rarely used together at full strength in decor or printing, except at holiday time. To lessen the Christmas feeling, use tints or shades. Or combine two colors that are near-complements, rather than true complements. See the following pages for red/green combinations that say more than Merry Christmas.

Friends and Lovers

Notice the difference between complements and related warm-cool pairs from the previous chapter. Related hues, five steps apart, are chosen from the same side of the warm-cool spectrum; complements, by contrast, are opposites or vertical matches from the charts on the preceding pages.

Related hues are friendly companions that blend in close, easy harmonies. Conversely, complements fight, clash, shock, and create passion. Locked in competition, they are persistently vying for attention, sending out contradictory messages. One shouts stop, the other shouts go. One advances, the other recedes. One is right-brain, the other left-brain.

Obviously it's important for the artist to take charge and make sure that the main color is not overpowered by its complement. Using a tint or a shade of a complement, rather than its full strength, can bring the opposing hue under control and still provide a sense of completeness to the overall picture.

Color Vision

While almost everybody can see some colors, some people do not perceive the full rainbow. Most color blindness problems occur in the red/green area, making it difficult to distinguish traffic signals. Usually this problem does not affect other visual functions or impede one's creative ability. See Page 147 for more information about color blindness.

Courtesy of Smith & Hawken

PHOTOGRAPHER *Chris Collins* ©

DESIGNER *Ivan Chermayeff*
Chermayeff & Geismar Inc. ©

COLOR BYTES

ARTIST Michael Dudash ©

Courtesy of Scalamandre Silks, Inc.©
Palazzo Pallavincini Fabric 100% Silk Lampa

COLOR BYTES

ARTIST Thomas Pradzynski
Exclusive Agents
Caldwell Snyder Fine Art, San Francisco

Courtesy of Scully & Scully Inc.©

Bourges Collection ©

ARTIST Wade S. Thompson ©

ARTIST Keith Puccinelli ©

106

VECTA
D
Design Issues

DESIGNER AND ILLUSTRATOR **Milton Glaser ©**

Courtesy of Oneida Ltd.©
Tom R. Ross , V.P. Advertising

COLOR BYTES

YELLOWS BLUES

"B" COMPLEMENTS HAVE THE MOST VARIETY

| 6 | 16 | | 7 | 17 | | 8 | 18 | | 9 | 19 | | 10 | 20 |

CORAL
and
CYAN

ORANGE
and
SKY BLUE

AMBER
and
ULTRAMARINE

GOLD
and
VIOLET

YELLOW
and
PURPLE

Rainbow Within a Rainbow

Not a conventional rainbow that mirrors the spectrum, the yellow/blue group is like a designer's palette of ten bright colors, from hot red orange to yellows and true blues to rich, strong purples. These colors function as five sets of complements, with warm yellows on the top row and cool blues on the bottom. When the artist pairs these warm and cool hues, magical combinations result, which can all be easily matched with process colors.

Because B-complements contain a wider variety of colors, they are more interesting to use than the more striking red/green combinations. This group actually contains three different types of complements: The first is the yellow/blue variety, a term used by CIELAB laboratories as the category for the entire range of B-complements. The others are the orange/blue and yellow/purple varieties familiar to artists and students.

Sun–Sky Complements

Technically, *yellow* and *cyan* are not really complements as they don't produce black when combined. However, they do convey opposing thoughts. Pairing yellows and blues creates an emotional dichotomy. Generally, yellows are inspiring, exciting, and full of energy, whereas blues are serene, reserved, and level-headed. Yet it is the strength of these conflicting moods that holds these divergent colors together.

Think of the sizzling energy of yellow teamed with icy blue or the hot golden sun offset by the cool, calm sky. Unlike the earth-based red/green combinations, these yellow/blue pairs are the distant colors of Father Sky. Not necessarily friendly pairs, they create tension, producing visually exciting results in art and in graphics, other than creating green.

More aloof than the reds and greens, these hues are less personal, less emotional, and better suited to intellectual pursuits. It is no accident that yellow/blue combinations are a favorite color choice among schools and universities, those respected citadels of learning and order.

Follow the Leaders

Consider, at right, the branches of these pale yellow flowers held in a simple porcelain blue vase, so understated, yet so lovely that nothing else is needed. On the following pages, these yellow/blue complements are shown first, followed by the orange/blue and yellow/purple combinations.

Courtesy of The Metropolitan Museum of Art

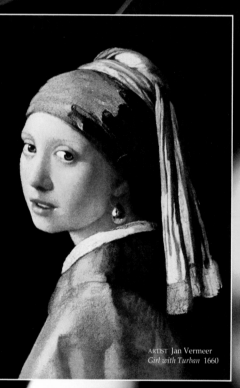

ARTIST Jan Vermeer
Girl with Turban 1660

Courtesy of Mikasa
ART DIRECTOR Rob Wheale
DESIGNER Bernadino
PHOTOGRAPHER Joel Cipes

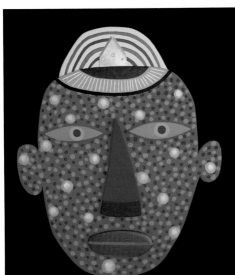

ARTIST Chad Knapec

Emperor Anglefish Courtesy of Océ USA Inc.

Courtesy of the Greek
National Tourist Organization

ARTIST Jane Wooster Scott
Aroma of the Gods

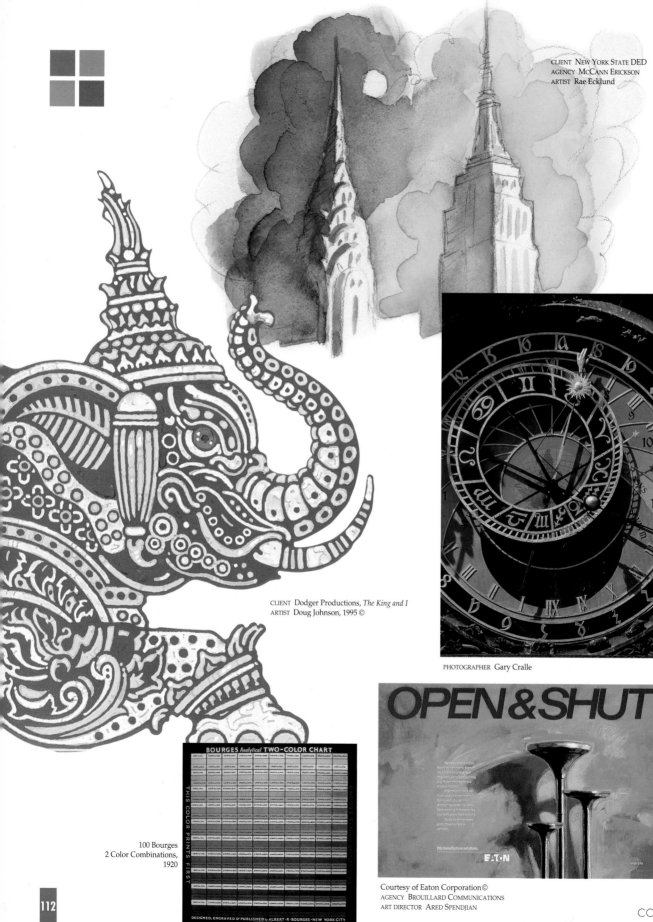

CLIENT New York State DED
AGENCY McCann Erickson
ARTIST Rae Ecklund

CLIENT Dodger Productions, *The King and I*
ARTIST Doug Johnson, 1995 ©

PHOTOGRAPHER Gary Cralle

100 Bourges
2 Color Combinations,
1920

OPEN & SHUT

We manufacture solutions.

E·A·T·N

Courtesy of Eaton Corporation©
AGENCY Brouillard Communications
ART DIRECTOR Ared Spendjian

COLOR BYTES

David Jorba, Student of Graphic Design
Hank Richardson, Chair, Design Program, Portfolio Center, Atlanta, GA

FOUR COLOR HARMONY

*How to avoid
multicolor chaos
with well-planned
color schemes.
A new concept using
four basic colors,
spaced equally apart
in the spectrum.
A beautifully
balanced format
consisting of two sets
of complements &
two related pairs of color*

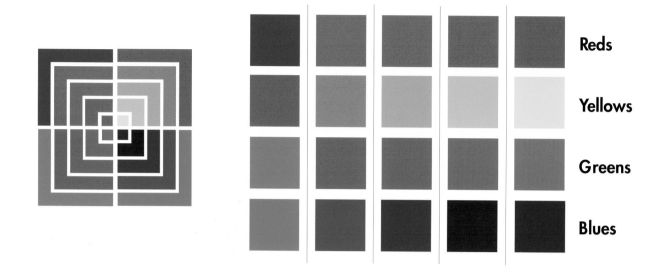

Reds

Yellows

Greens

Blues

Everything Comes Together

Each previous chapter brought you one step closer to using colors in a planned and orderly way. Profiles of individual colors were followed by shades, pairs of related colors, and complements. Now you can put together harmonious groups of four colors and navigate the process maze within a simple structure.

Believing that more is better, beginners often find themselves tempted to use a multitude of colors. In a major painting and in the hands of a skilled artist, chaotic color may work. But if your purpose is to tell a story, or send a clear message, confusion is your enemy. You need a plan, a structure that will enable you to use colors as functional design elements.

On this page, swatches from the four color groups are positioned over one another, forming a 20-box rectangle. Cutting the large rectangle into vertical slices provides guidelines for creating five basic color schemes, each containing a square of red, yellow, green, and blue. The four hues in each vertical set are selected to work well together.

Each set contains two pairs of complements, one pair of warm colors and one of cool, providing a carefully balanced palette and an excellent place to start. From here you can tip the scales in many directions, adding tints, grays, and blends to refine the choices. Let your personal experience and inspiration be your guide.

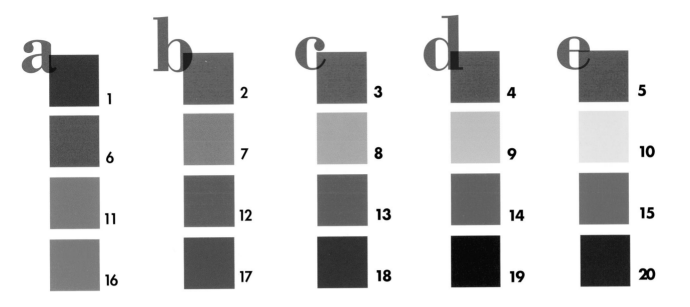

Taming the Fauvist Palette

The fauvists were concerned with creating a single original painting. Color match was not important. Printing was just another creative craft and computers were not even in their dreams. Today the colors we use continue to speak to the emotions, but they can be process colors with numbers, coded for implementation through new technologies.

The colors of the Bourges System have been described as fauvist because they start out as pure, bright basic hues. The tints, shades, and blends come later to create a fully developed color system. These artists were all skilled painters, familiar with the theories of Sir Isaac Newton and M.E. Chevreul. They explored the spectrum in ways that had never been done before. Their subjects were simple and their techniques varied. There were no formal rules or hidden political messages, just the excitement and pure joy of color itself.

Find your theme color in one of the five balanced sets above. It will be positioned together with its related hues and complements. Each set contains one each of the reds, yellows, greens, and blues, carefully chosen to give you a multicolor palette with built-in color harmony. Study the following pages to see each set in action, with a variety of images, complete tonal scales, and the positions of the related hues and complements in a Bourges color circle.

Albert Marquet, *The Beach at Trouville* 1906,
Courtesy of the Mrs. John Hay Whitney Collection©

Just Two Years

The Fauvists exploded on the art scene in 1905-1906 and changed forever the ways artists used color. There was now an easier freer style that would include the colors themselves as a key factor. Study their work, start a collection. There are many subjects, styles, and techniques and many explorers like Marquet, Rouault, Vlaminck, Dufy, and Matisse.

Famous Color Circles

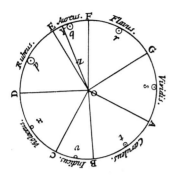

1. Sir Isaac Newton (1642-1727)
English mathematician and scholar who brought color into the world of science with his discovery that color was light and therefore, the colors of objects were the result of reflected light. His famous book *Optics* was published in 1704.

2. Moses Harris (1731-1785)
Entomologist, artist, and engraver who created the rarest book in the literature of color. In 1766, *The Natural System of Colors*, was printed in England using three primary colors and including the first known circle image in full color.

3. Michel E. Chevreul (1786-1889)
French chemist whose color theories strongly influenced the works of the impressionist painters. His classic text *The Principles of Harmony and Contrast of Colors* published in 1839, had 742 pages and a separate atlas of 40 color plates.

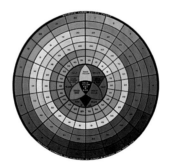

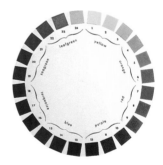

4. Albert H. Munsell (1858-1918)
Boston art instructor arranged colors by appearance, using equal visual steps of hue value and chroma. This system was actively promoted with teaching materials. His *Color Atlas* with handpainted swatches was published in 1915.

5. Albert R. Bourges (1881-1955)
American photoengraver and inventor who published in 1918 a color notation system that identified color in process-printing terms. An early advocate of color standards, he wrote and lectured extensively about the use of color in the graphic arts.

6. Friedrich W. Ostwald (1853-1932)
German chemist and winner of the 1909 Nobel Prize in chemistry who developed a more scientific color theory and taught in the Weimar Bauhaus (1919-1933). He wrote two important color books, *Color Science* (1923) and *Farbentafeln* (1934).

See Page 156 for image credits

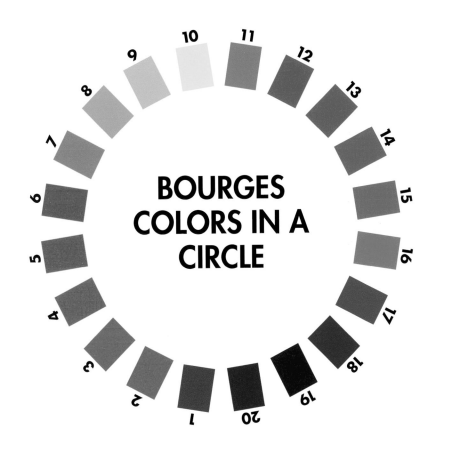

BOURGES COLORS IN A CIRCLE

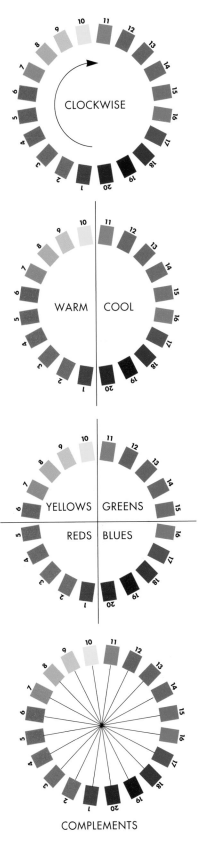

Throughout this book, the spectrum has been charted as a linear strip of color, with an obvious beginning and end. But as you delve further into multicolors, it is also important to see where the colors are positioned on the color wheel, which is a familiar teaching format.

However, color circles can be confusing as they tend to look alike, yet may contain quite different information. For example, in the circles at the left, Newton identifies seven basic colors; Harris, three; Munsell, five; and Ostwald, four. The Munsell sequence is reds, then yellows, whereas Ostwald puts the yellows first and then the reds. Sipley noted this as counterclockwise.

The Bourges circle starts with *mauve*, at the bottom, which puts *yellow* at the top, in the same position as the *yellow* in the CIE-LAB chart. The colors move clockwise, with the warm colors on the left and the cool colors on the right. The halves are then broken into quarters, or four basic color groups. In the last diagram, all of the colors are connected to their direct complements.

On the following pages, circle diagrams illustrate each of the five color groups; each contains two sets of complements and a warm and cool pair of colors, shown by the connecting lines inside each circle. The complements are positioned at right angles and the related pairs are shown in the warm or cool part of the circle.

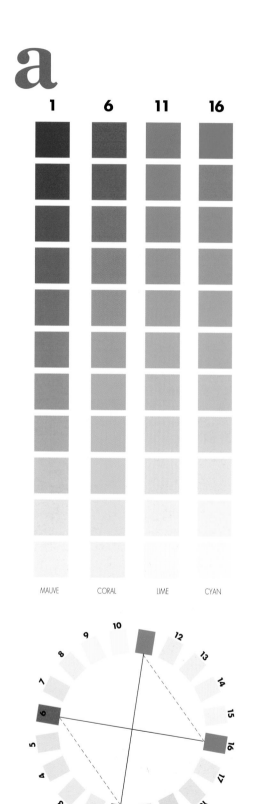

MAUVE CORAL LIME CYAN

——— Compliments – – – Related Hues

Follow the Masters

Art can be created on a table napkin, a canvas, or a computer screen. Computers offer limitless capabilities to artists, making it possible to design by video screen. In a matter of seconds, the artist can reduce an image or enlarge it, place it on a straight line or twist it into a circle, change the hue or remove it entirely, make the colors flat and smooth or add texture.

If you are a master at painting on paper, creating on a computer monitor may seem impossible or intimidating. Yet for centuries artists have been challenged by technological changes. Prior to photographic process printing, artists who wanted their works reproduced had to learn how to carve out wooden blocks or draw on lithographic stones.

But if you are computer literate, you have an advantage. You can build upon your skills by learning to identify the colors in this book and match them on your computer, while manipulating the images in ways that were never possible before.

Follow the Masters

A bonus of improved color technology is the excellent quality of the color reproductions of fine art prints. They are reasonably priced and readily available so that you can easily build a private collection of art prints without leaving your home. These prints can be a source of inspiration; look for those with distinctive color schemes.

The colors of this image from the garden at Giverny by Claude Monet can be used for a business report, sales chart, or even a stage set. The colors work well together, one of the reasons the work is considered a masterpiece. So study it and use it as a reference. You will be following in the well-traveled paths of artists who have spent their lives exploring the secrets of color.

The four basic colors of this painting are distinctive, giving a particular character to the image. The main theme color is *mauve*, which is enhanced with *coral* to extend this warm color effect. Patches of *lime* and *cyan* increase the contrast to fill out the spectrum, creating a full and balanced color scheme.

Claude Monet, *A Garden at Giverny*

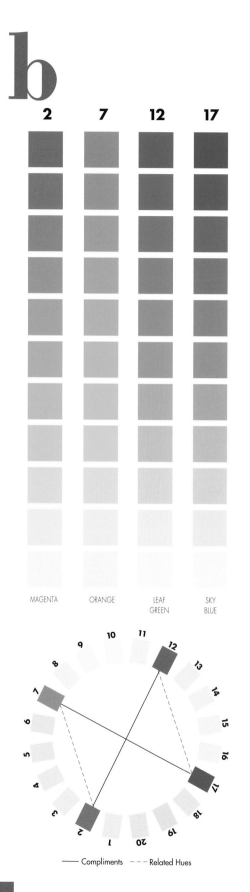

2	7	12	17

MAGENTA | ORANGE | LEAF GREEN | SKY BLUE

—— Compliments - - - Related Hues

The Art of Fabric

Bolts of beautiful fabric colors and patterns can send your imagination reeling. Every fabric store you visit, whether it's in the same city or an entirely different country, broadens the spectrum of possibilities, making it almost impossible to choose. It may not surprise you that most people choose their clothing by color, and habit prompts them to return to reliable, familiar hues.

Knowing the personality of each color, explained in the profiles, is important in selecting fashions and furnishings. The pure, bolder colors appeal to the adventurous, while the softer, muted tones attract the more conservative. Certainly, a mood or an attitude on a given day can influence your color choices. Fabric designs in particular require a virtually endless number of color combinations and this system provides new focus for your choices.

Add a Yellow

In creative color, there is no such thing as right or wrong, no strict or absolute rules, just some basic guidelines to lead you in the right direction. In this section a fifth color has been added to enhance the visual effect, giving character and personal identity to the color schemes.

Yellow is a special color. While it is hard to see by itself, it works with other hues to add more light into the picture. The other hues remain virtually unaffected by its addition. Often artists will use touches of *yellow* to guide the viewer through the painting into the core of the image. Like magic, the eye is irresistibly drawn to this color. This will also work for you.

Inkjet Printing

Fabric designers have made good use of digital technology as computers can quickly and easily change the colors of the design patterns. This text shows us how the spectrum works; this system makes it easy to manipulate the colors as the artist would with a set of paints. The difference is the quality control that the new technology provides for conventional process as well as for inkjet printing in which many colors are printed at the same time.

Courtesy Scalamandré Silks, Inc.
"Carnival Stripe" 100% Silk Taffeta

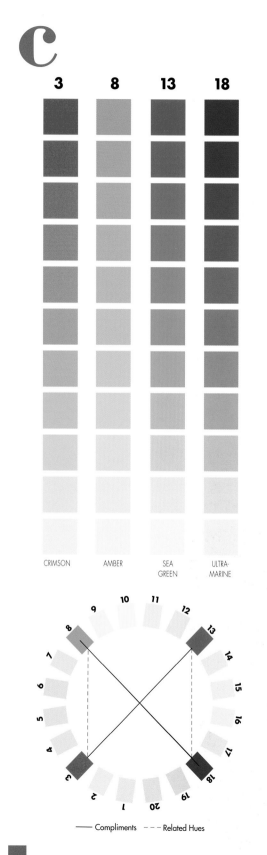

3	8	13	18

CRIMSON | AMBER | SEA GREEN | ULTRA-MARINE

—— Compliments – – – Related Hues

Four Colors Are Enough

Dramatic colors get attention. Just four colors are enough to stop the viewer with an image that is easily remembered. The simplicity of this poster combines the color freedom of a fauvist painter with the precision of a skilled graphic designer. With one hue from each of the four color groups, the whole spectrum is covered. In this painting, the four selected hues are each an equal distance apart on the Bourges chart, placing each in the same relative position within the reds, yellows, greens, and blues, making this a very easy pattern to follow.

Today, printing in a rainbow of beautiful color no longer makes a work distinctive. What sets a piece apart from thousands of others is the designer's ability to cull from the infinite selection of colors and pick those balanced hues that give a work a special character.

When Less Is Better

This philosophy, long adhered to by fine painters, is clearly demonstrated here. Not only is this work richly textured and dramatically painted, but the palette is intentionally limited to a perfectly balanced set of just four colors. Though the color usage is restricted, viewers don't sense that something is missing. All of the elements of good color design are here. It takes great confidence to handle color like this, but the result is worth it and won't easily be forgotten. Compare the colors at left and see how effectively they are handled in the painting. Using just these simple flat tones, everything works perfectly together and will for you as well. Not a pure process color in the lot, these are truly painters' colors translated by the computer into printers' terms.

Think in Pairs

With lots of practice, you can build up your confidence, make disciplined choices, and work boldly with related hues and complements. First experiment with individual colors; then work up to pairs. Since the complements are the most important color combinations, think of them as the prime pairs. Pick up your paintbrush or go to your computer and practice, practice, practice. Reading is a good start, but real learning comes from hands-on experience again, again, and again.

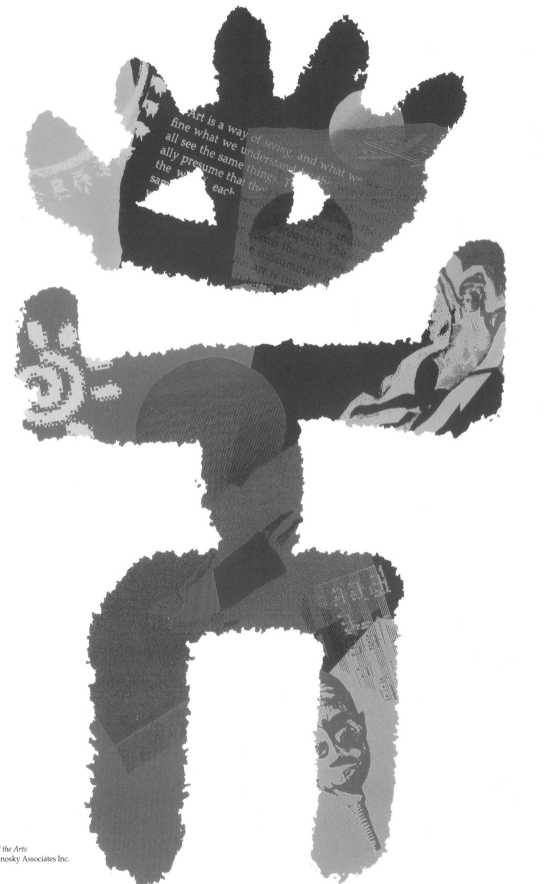

POSTER *Mythology and the Arts*
DESIGN Cook and Shanosky Associates Inc.

4	9	14	19

SCARLET — GOLD — EMERALD — VIOLET

—— Compliments - - - Related Hues

Across Many Platforms

Since color is both light and reflected light, which work in very different ways yet use the same terms, communicating about the dual nature of color can be difficult. Photographers are right: color is light. But artists have had many centuries of working with color, one brush stroke at a time.

Pigment terms are easily taught; more people can understand that red and yellow make orange because they can easily see it happen with colored pencils, markers, or paint. So when one asks for more red, use the artists' term, and for process printing, *magenta*.

Red and Green Do Not Make Yellow

At least not in any artist's palette, but they do create yellow on film, the monitor, the movie screen, or anywhere that color is created by light. The first computers only worked in RGB, but now they also work in CMY, *cyan-magenta-yellow*, the pigment language that is shown in this text. Soon what you see on the screen can be the same as what you see in print, as the monitor will include the true print gamut.

Photography is art and art is photography. The image could be a pastel sketch, a serious painting, or a freeze-frame from a roll of film. The source doesn't matter; it is shown here for the colors, which the new commercial standards can match in most any medium.

Multimedia Doesn't Change the Colors

Fabric, posters, paintings, and television are all governed by the same fundamentals of color that are shown here. Sound and motion just enhance the visual effect. Leonardo and Michelangelo would probably have used the same colors today if they were creating an epic film.

What has changed in this century is the technical equipment. In the 1930s, when my uncle Fernand Bourges photographed the images for Condé Nast, he noted that the camera's shutter speed was 1/50th of a second. It is now many thousandths of a second, allowing these images to catch the runner in motion, which not too long ago could only be imagined by the artist.

PHOTOGRAPHER Bruce Wodder
Photo Runner

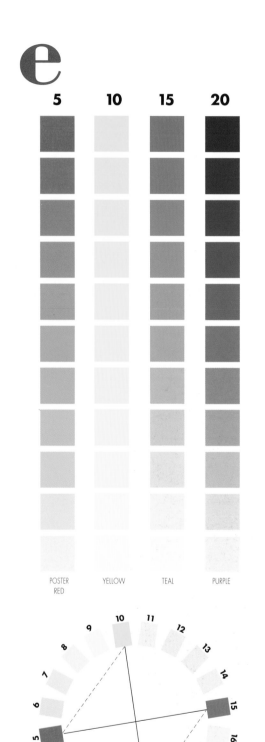

POSTER RED YELLOW TEAL PURPLE

—— Compliments - - - Related Hues

Color Is Talking

Though you may not hear it, your psyche is responding, either to confirm a message or tell a different story. Adding color indiscriminately just to make your work look more interesting can actually confuse the message, creating conflict. These umbrellas illustrate the information of a simple chart, document, or diagram. Here are some basic guidelines:

What the Colors Say

Select the color of your umbrella according to the information it conveys. It will reinforce that message throughout your presentation. Color is the simplest and most effective identity code in existence. It works instantly every time. No thinking is required as people respond instinctively to color, whether they want to or not.

See me first – This is the most important. Reds naturally take this position. Let them work for you as attention-getters.

The sun will shine tomorrow – perhaps gloriously. Yellows give the promise of future success and prosperity.

Things that work – and hopefully pay off. Greens are the colors of life and money and the steady rhythms of efforts well done.

Planning and order – make everything work better. Blues are best to show facts and supporting data without creating conflict.

All the chromatic patterns in this chapter are basically the same. These practical, well-balanced color combinations can be easily followed for your needs, whether they are for a creative hobby, package design, direct mail, or an advertisement on the Internet.

Choosing colors is no longer a mystery. These art concepts are a distilled summary of theories that have been proven to work. Now you know exactly which colors go together, how they work, and why. A fixed palette gives you something to use that can be learned and mastered. The challenge is to grab hold of a reasonable number of measured colors and learn how to use them effectively.

PHOTOGRAPHER Michel Tcherevkoff

CHAPTER 7

POSTSCRIPT

The story of this electronically produced book. Its background, how type & art were generated, the pre-press & printing. Also a summary of the creative guidelines, master charts with CMYK codes, & print control standards.

BOURGES MASTER CHART

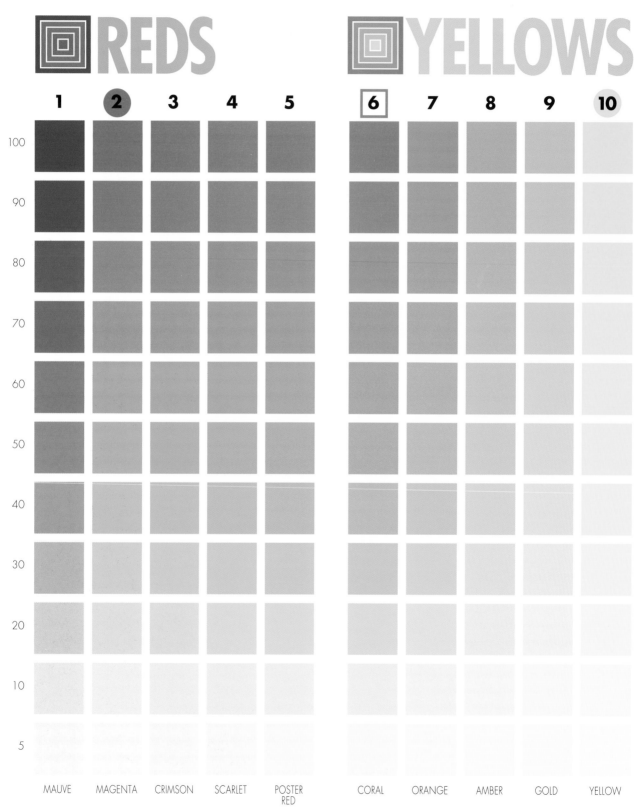

REDS

YELLOWS

	1	2	3	4	5		6	7	8	9	10

100

90

80

70

60

50

40

30

20

10

5

MAUVE MAGENTA CRIMSON SCARLET POSTER RED

CORAL ORANGE AMBER GOLD YELLOW

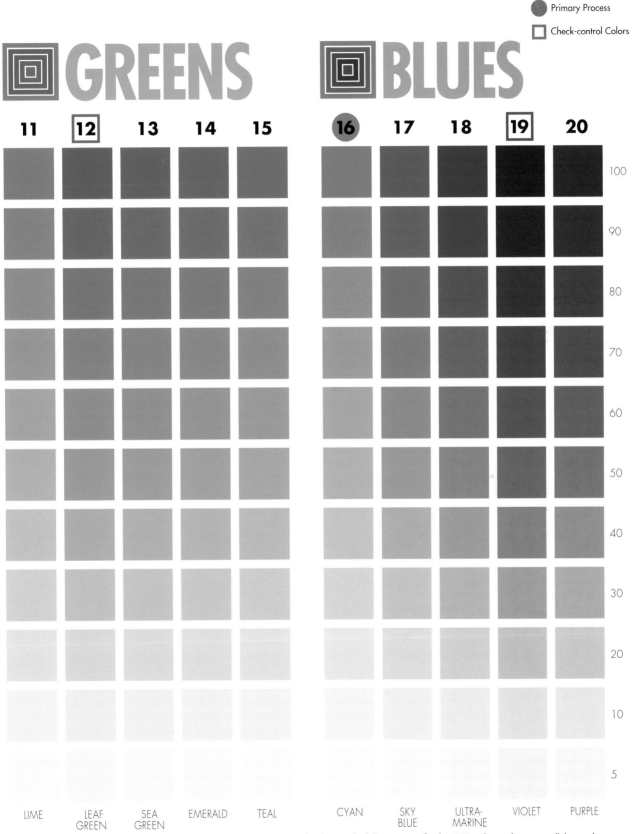

GREENS

BLUES

Primary Process

Check-control Colors

11	12	13	14	15		16	17	18	19	20	

100
90
80
70
60
50
40
30
20
10
5

LIME LEAF GREEN SEA GREEN EMERALD TEAL

CYAN SKY BLUE ULTRA-MARINE VIOLET PURPLE

See the chart on the following page for the CMY codes used to create all these colors.

BOURGES PROCESS CODES

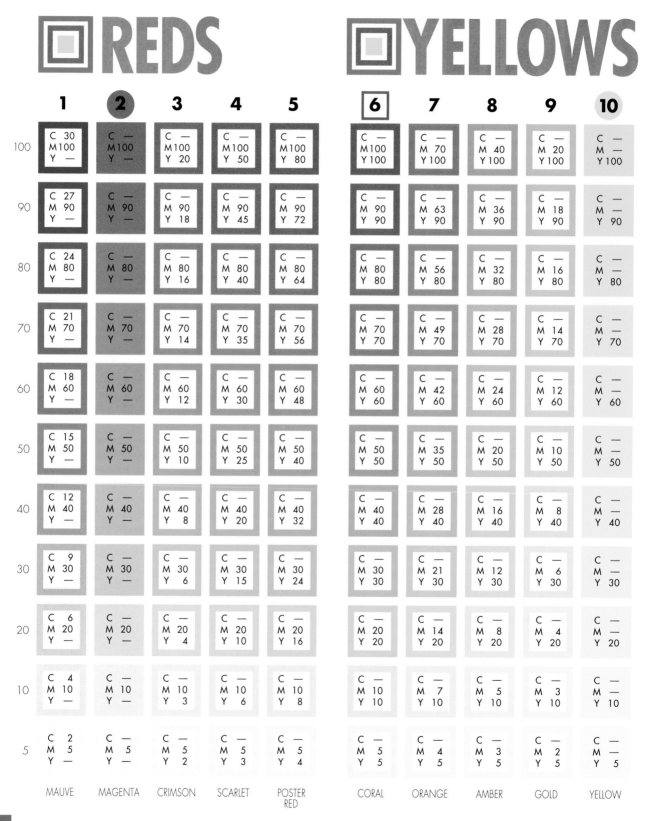

REDS / YELLOWS

	1 MAUVE	2 MAGENTA	3 CRIMSON	4 SCARLET	5 POSTER RED	6 CORAL	7 ORANGE	8 AMBER	9 GOLD	10 YELLOW
100	C 30 / M 100 / Y —	C — / M 100 / Y —	C — / M 100 / Y 20	C — / M 100 / Y 50	C — / M 100 / Y 80	C — / M 100 / Y 100	C — / M 70 / Y 100	C — / M 40 / Y 100	C — / M 20 / Y 100	C — / M — / Y 100
90	C 27 / M 90 / Y —	C — / M 90 / Y —	C — / M 90 / Y 18	C — / M 90 / Y 45	C — / M 90 / Y 72	C — / M 90 / Y 90	C — / M 63 / Y 90	C — / M 36 / Y 90	C — / M 18 / Y 90	C — / M — / Y 90
80	C 24 / M 80 / Y —	C — / M 80 / Y —	C — / M 80 / Y 16	C — / M 80 / Y 40	C — / M 80 / Y 64	C — / M 80 / Y 80	C — / M 56 / Y 80	C — / M 32 / Y 80	C — / M 16 / Y 80	C — / M — / Y 80
70	C 21 / M 70 / Y —	C — / M 70 / Y —	C — / M 70 / Y 14	C — / M 70 / Y 35	C — / M 70 / Y 56	C — / M 70 / Y 70	C — / M 49 / Y 70	C — / M 28 / Y 70	C — / M 14 / Y 70	C — / M — / Y 70
60	C 18 / M 60 / Y —	C — / M 60 / Y —	C — / M 60 / Y 12	C — / M 60 / Y 30	C — / M 60 / Y 48	C — / M 60 / Y 60	C — / M 42 / Y 60	C — / M 24 / Y 60	C — / M 12 / Y 60	C — / M — / Y 60
50	C 15 / M 50 / Y —	C — / M 50 / Y —	C — / M 50 / Y 10	C — / M 50 / Y 25	C — / M 50 / Y 40	C — / M 50 / Y 50	C — / M 35 / Y 50	C — / M 20 / Y 50	C — / M 10 / Y 50	C — / M — / Y 50
40	C 12 / M 40 / Y —	C — / M 40 / Y —	C — / M 40 / Y 8	C — / M 40 / Y 20	C — / M 40 / Y 32	C — / M 40 / Y 40	C — / M 28 / Y 40	C — / M 16 / Y 40	C — / M 8 / Y 40	C — / M — / Y 40
30	C 9 / M 30 / Y —	C — / M 30 / Y —	C — / M 30 / Y 6	C — / M 30 / Y 15	C — / M 30 / Y 24	C — / M 30 / Y 30	C — / M 21 / Y 30	C — / M 12 / Y 30	C — / M 6 / Y 30	C — / M — / Y 30
20	C 6 / M 20 / Y —	C — / M 20 / Y —	C — / M 20 / Y 4	C — / M 20 / Y 10	C — / M 20 / Y 16	C — / M 20 / Y 20	C — / M 14 / Y 20	C — / M 8 / Y 20	C — / M 4 / Y 20	C — / M — / Y 20
10	C 4 / M 10 / Y —	C — / M 10 / Y —	C — / M 10 / Y 3	C — / M 10 / Y 6	C — / M 10 / Y 8	C — / M 10 / Y 10	C — / M 7 / Y 10	C — / M 5 / Y 10	C — / M 3 / Y 10	C — / M — / Y 10
5	C 2 / M 5 / Y —	C — / M 5 / Y —	C — / M 5 / Y 2	C — / M 5 / Y 3	C — / M 5 / Y 4	C — / M 5 / Y 5	C — / M 4 / Y 5	C — / M 3 / Y 5	C — / M 2 / Y 5	C — / M — / Y 5

GREENS BLUES

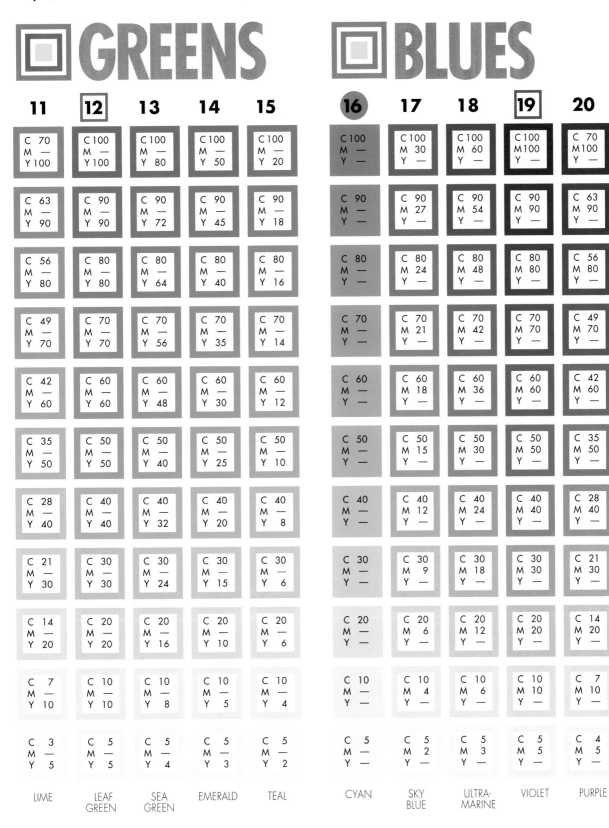

	11	12	13	14	15	16	17	18	19	20	
	C 70 / M — / Y 100	C 100 / M — / Y 100	C 100 / M — / Y 80	C 100 / M — / Y 50	C 100 / M — / Y 20	C 100 / M — / Y —	C 100 / M 30 / Y —	C 100 / M 60 / Y —	C 100 / M 100 / Y —	C 70 / M 100 / Y —	100
	C 63 / M — / Y 90	C 90 / M — / Y 90	C 90 / M — / Y 72	C 90 / M — / Y 45	C 90 / M — / Y 18	C 90 / M — / Y —	C 90 / M 27 / Y —	C 90 / M 54 / Y —	C 90 / M 90 / Y —	C 63 / M 90 / Y —	90
	C 56 / M — / Y 80	C 80 / M — / Y 80	C 80 / M — / Y 64	C 80 / M — / Y 40	C 80 / M — / Y 16	C 80 / M — / Y —	C 80 / M 24 / Y —	C 80 / M 48 / Y —	C 80 / M 80 / Y —	C 56 / M 80 / Y —	80
	C 49 / M — / Y 70	C 70 / M — / Y 70	C 70 / M — / Y 56	C 70 / M — / Y 35	C 70 / M — / Y 14	C 70 / M — / Y —	C 70 / M 21 / Y —	C 70 / M 42 / Y —	C 70 / M 70 / Y —	C 49 / M 70 / Y —	70
	C 42 / M — / Y 60	C 60 / M — / Y 60	C 60 / M — / Y 48	C 60 / M — / Y 30	C 60 / M — / Y 12	C 60 / M — / Y —	C 60 / M 18 / Y —	C 60 / M 36 / Y —	C 60 / M 60 / Y —	C 42 / M 60 / Y —	60
	C 35 / M — / Y 50	C 50 / M — / Y 50	C 50 / M — / Y 40	C 50 / M — / Y 25	C 50 / M — / Y 10	C 50 / M — / Y —	C 50 / M 15 / Y —	C 50 / M 30 / Y —	C 50 / M 50 / Y —	C 35 / M 50 / Y —	50
	C 28 / M — / Y 40	C 40 / M — / Y 40	C 40 / M — / Y 32	C 40 / M — / Y 20	C 40 / M — / Y 8	C 40 / M — / Y —	C 40 / M 12 / Y —	C 40 / M 24 / Y —	C 40 / M 40 / Y —	C 28 / M 40 / Y —	40
	C 21 / M — / Y 30	C 30 / M — / Y 30	C 30 / M — / Y 24	C 30 / M — / Y 15	C 30 / M — / Y 6	C 30 / M — / Y —	C 30 / M 9 / Y —	C 30 / M 18 / Y —	C 30 / M 30 / Y —	C 21 / M 30 / Y —	30
	C 14 / M — / Y 20	C 20 / M — / Y 20	C 20 / M — / Y 16	C 20 / M — / Y 10	C 20 / M — / Y 6	C 20 / M — / Y —	C 20 / M 6 / Y —	C 20 / M 12 / Y —	C 20 / M 20 / Y —	C 14 / M 20 / Y —	20
	C 7 / M — / Y 10	C 10 / M — / Y 10	C 10 / M — / Y 8	C 10 / M — / Y 5	C 10 / M — / Y 4	C 10 / M — / Y —	C 10 / M 4 / Y —	C 10 / M 6 / Y —	C 10 / M 10 / Y —	C 7 / M 10 / Y —	10
	C 3 / M — / Y 5	C 5 / M — / Y 5	C 5 / M — / Y 4	C 5 / M — / Y 3	C 5 / M — / Y 2	C 5 / M — / Y —	C 5 / M 2 / Y —	C 5 / M 3 / Y —	C 5 / M 5 / Y —	C 4 / M 5 / Y —	5
	LIME	LEAF GREEN	SEA GREEN	EMERALD	TEAL	CYAN	SKY BLUE	ULTRA-MARINE	VIOLET	PURPLE	

Digital Shorthand

BOURGES 20 MASTER CHART *(20 profile codes with computer extrapolated tints)*

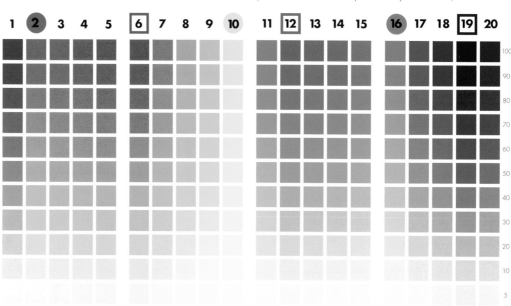

All the color charts and diagrams you have seen previously throughout the book have been created with the exact CMY codes show on the preceding pages, using 220 custom colors. *The chart above was created using the CMY codes for the 20 Bourges profile colors and letting the computer extrapolate the tints, 90%, 80%, etc.* A 20 custom color palette is more manageable to a computer artist or designer for production than 220 individual colors. The results are close and can be compared here with the original chart below.

BOURGES 220 MASTER CHART *(individual 220 codes see Pages 134-135)*

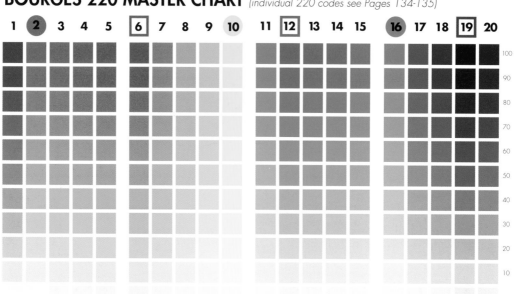

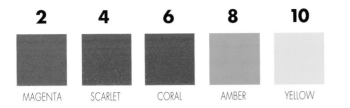

2	**4**	**6**	**8**	**10**
MAGENTA	SCARLET	CORAL	AMBER	YELLOW

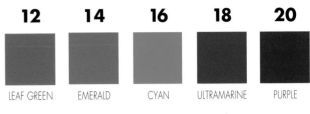

12	**14**	**16**	**18**	**20**
LEAF GREEN	EMERALD	CYAN	ULTRAMARINE	PURPLE

Just Ten Colors

If 20 colors are too many, you can use half the Bourges palette instead. Across the top of this page is an abbreviated spectrum that contains only the even-numbered colors, 2, 4, 6, etc. These work together like the full master chart but are easier to learn and are recommended for those just starting to study color. Then when you're ready, the odd-numbered colors can be inserted and everything will be in its correct position.

This half-spectrum of color contains all the hues that are essential for graphic arts and computer work. The primary colors of process printing, with the important secondary colors of *coral, leaf green*, and *purple* provide perfect sets of complements. The other in-between colors (*scarlet, emerald, amber, and ultramarine*) round out the palette (*see chart bottom right*). The warm colors are on top and the cool colors below. The complements remain ten steps apart and are easy to find.

Color Is Fun

Using color is a joy, not just for artists but virtually everyone. You can create designs the traditional way, with art materials, or directly on the computer. All you need to do is choose the colors, deciding whether to use them full strength, in the lighter tints, in shades, or blended. With this system in place, everything will come together, on paper or on the screen.

Picasso is supposed to have said that everyone is an artist at age two. It's fun to watch children take delight in experimenting with crayons and paints. And in senior centers, older people rediscover their innate love of color. But too often, during busy times, adults set aside such pleasures. This system is designed to help everyone rediscover color, a never-ending source of joy.

Courtesy of QMS, Inc.
ART DIRECTOR Hank McDaniel, Greenstone Roberts Adv. PHOTOGRAPHER Rick Bostik

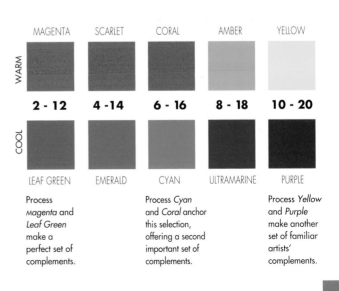

	MAGENTA	SCARLET	CORAL	AMBER	YELLOW
WARM					
	2 - 12	**4 -14**	**6 - 16**	**8 - 18**	**10 - 20**
COOL					
	LEAF GREEN	EMERALD	CYAN	ULTRAMARINE	PURPLE

Process *Magenta* and *Leaf Green* make a perfect set of complements.

Process *Cyan* and *Coral* anchor this selection, offering a second important set of complements.

Process *Yellow* and *Purple* make another set of familiar artists' complements.

 GREENS

Notes: Complex Combinations

This is the real challenge of your new color education. If you have started with the basic fundamentals of the preceding chapters, the colors have all had a clear identity. Now it is time to explore what happens with the blended hues of the process world.

First turn to Page 133 to see the same chart of greens as printed here. Then turn to Page 135 for the process codes that created these colors. You will note that they all consist of cyan and yellow; the magenta is the mpc, missing process color.

By using combinations of no more than two process hues, the colors are brighter and more separate from each other. By adding a flat tint of the missing process color or colors, everything is radically changed as shown on the adjoining page. Now there are softer greens, foggy blues, subtle pinks, and almost neutral grays.

All the Bourges colors have just one or two process components (see Pages 134-135). This means that every one of these 220 colors can be similarly changed by adding any tint of the missing process hues.

Process standards are in place. The technology is available to print all these colors. The challenge is to learn the basics, get experience, and find exactly what you want in CMY numbers.

30% MAGENTA
(The mpc missing process color)

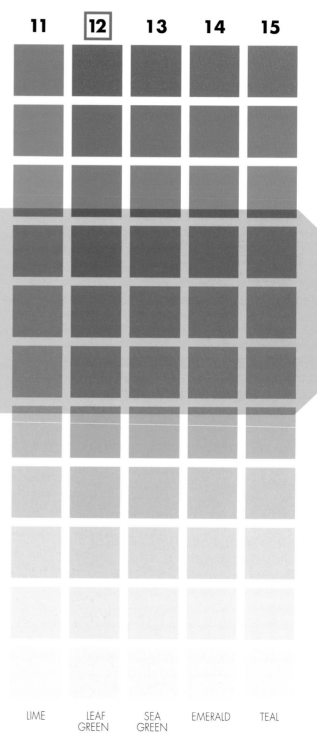

| 11 | 12 | 13 | 14 | 15 |

| LIME | LEAF GREEN | SEA GREEN | EMERALD | TEAL |

BLENDS

Multiply the Colors

11	**12**	13	14	15

Computers boast that they can deliver millions of colors, but that is of very little comfort to the user if there is no way to connect this capability to finding specific colors that are wanted. Color schemes are conceived with only a few colors, as covered in Chapter 6. Using all the colors that are available would create chaos and give no clue to the viewer about the intended message.

The benefit of these high-tech quality controls is that the process-color match is there when you want it, not just once in a while when special effort is made, but rather as part of the daily production routine to use as needed. This means the dawn of a new era in graphic arts, when both simple and complex colors can be matched.

These Are Fuzzy Colors

This is the realm of the vague muted hues, easy to achieve by blending the artist's colors on a palette. Artists get wonderful results, which are very hard to duplicate. However, blends are not magic and not necessary to handle as spot color. You are in control and the new technology will follow your instructions for these sophisticated blends.

Fuzzy colors are not like the clear bright colors of the master chart. They are mixtures that diffuse the thought and blur the meaning. Top designers prefer them because they give a more sophisticated message, one that is indirect and more polite. They are often used for expensive fabrics and elegant furnishings, offering something rare and special, rather than a mass marketed product which requires instant recognition.

LIME	LEAF GREEN	SEA GREEN	EMERALD	TEAL

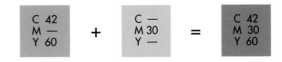

$$
\begin{array}{c}
C\ 42 \\
M\ — \\
Y\ 60
\end{array}
\quad + \quad
\begin{array}{c}
C\ — \\
M\ 30 \\
Y\ —
\end{array}
\quad = \quad
\begin{array}{c}
C\ 42 \\
M\ 30 \\
Y\ 60
\end{array}
$$

20 Bourges Mosaics

50% Tint + 30% mpc	50% TINT	50% Tint + 50% mpc
RELATED HUE	BASIC HUE	COMPLE MENT
50% Tint + 10% mpc	+50%K SHADE	50% Tint + 70% mpc

Scan these squares to quickly select a color scheme. Use these pages to find other colors that are balanced to work well with your theme hue. The diagram above gives the position and identification for each square, and descriptions are below.

 HUE – *The center square shows 100% of the pure basic profile color (see Chapter 2, pages 32-71).*

 TINT – *The 50% tint of the basic hue is shown above the center square (see Chapter 1, pages 24-25).*

 SHADE – *A black tint of 50% is added to the basic profile color (100%) and positioned directly under it (see Chapter 3, pages 74-77).*

 RELATED HUE – *The warm or cool related hue (100%) is to the left of the center square. For related pairs (see Chapter 4, pages 86 and 92).*

 COMPLEMENT – *To the right of this basic hue is its complement. For complement pairs (see Chapter 5, pages 100-102 and 108).*

 BLENDS – *In the four corners are muted hues created from the 50% tint of the basic profile color combined with four different tints of the missing mpc, process hue or hues (see pages 138-139).*

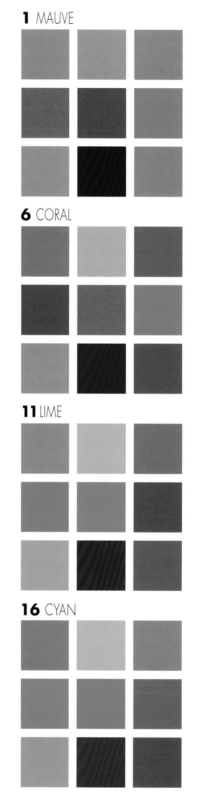

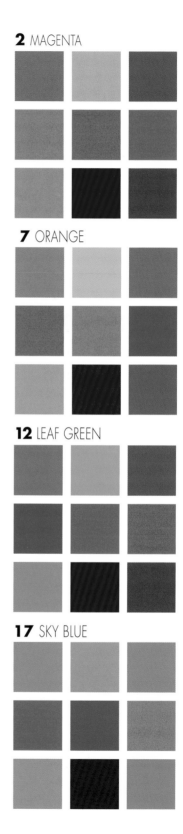

1 MAUVE

2 MAGENTA

6 CORAL

7 ORANGE

11 LIME

12 LEAF GREEN

16 CYAN

17 SKY BLUE

3 CRIMSON

4 SCARLET

5 POSTER RED

8 AMBER

9 GOLD

10 YELLOW

13 SEA GREEN

14 EMERALD

15 TEAL

18 ULTRAMARINE

19 VIOLET

20 PURPLE

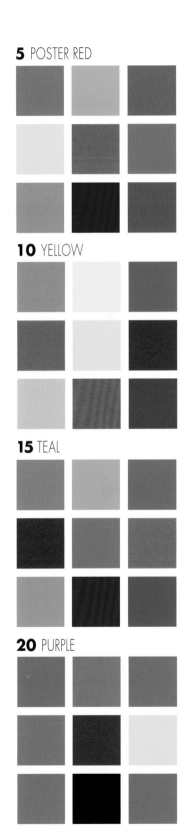

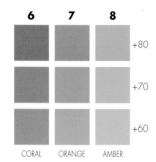

	6	7	8	
				+80
				+70
				+60
	CORAL	ORANGE	AMBER	

Add a 30% Green

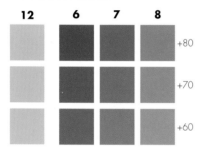

12	6	7	8	
				+80
				+70
				+60

Add a 30% Blue

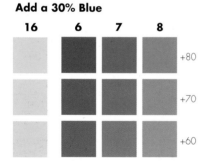

16	6	7	8	
				+80
				+70
				+60

Add a 30% Black

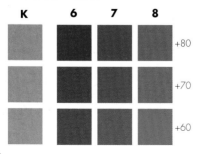

K	6	7	8	
				+80
				+70
				+60

Where Are the Browns?

No color has more variations or is harder to match than brown. There are no standards for these pigments, but even more important, an exact match requires an absolute degree of accuracy in all three colors of process printing.

First decide which brown you want: a warm earthy color, aubergine, taupe, or chocolate. In process printing, when a lighter cool color is added to a color composed predominantly of orange hues, combinations of *magenta* and *yellow,* the resulting color will be a variety of brown. If the added hue is the stronger color, the results will be grayer.

The four examples at left will show how this works. At the top is an assortment of orange squares taken from the second group of colors (yellows) from the Bourges master chart on Page 132. Any of these swatches can be used, even those from reds that include both *magenta* and *yellow* hues. These squares are used as the test base for the following browns.

Adding a cool color, in this case a flat tint of 30% *leaf green (12)*, abruptly changes the hue. Since each one of these orange bases is slightly different, notice the subtle changes in the browns.

The Browns are a Large Family

Next the same orange squares are combined with a flat tint of 30% *cyan (16)*, a pure third hue that contains neither *magenta* nor *yellow.* These results are slightly cooler and not quite as warm as the browns above, made with green, which added more yellow.

In this last example, the browns are achieved with the addition of a flat tint of 30% black (gray). It is not quite as rich as the other browns but is satisfactory and much easier to match. Check the charts of the shades in Chapter 3, Pages 74-77. You will find many different browns and their numerical references.

If brown is just a part of your overall color scheme, this information will give you basic guidelines. But if brown is a critical color, consider using a special ink. Or better still, ask your printer and follow his or her advice.

Expanding the Gamut... *from 20 to Infinity*

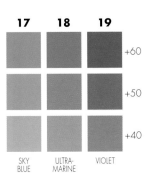

17	**18**	**19**	
			+60
			+50
			+40
SKY BLUE	ULTRA-MARINE	VIOLET	

Mathematical extrapolation offers about 6 billion colors that can be identified and matched in most computer programs. Since those are a lot more than we can see, the artist, who relies mostly on contrast and balance to achieve the best colors, uses a considerably smaller spectrum. Actually it is surprising to learn how few colors are needed, if you know how to choose the right ones.

But just in case you want more tints, shades, and blends, there is another step you can use. Bourges Charts show 10 steps of tint values; only enough to see and identify how the colors look when reduced. The technology now makes 1% increments a practical reality of quality color reproduction. Focus on the color area that comes closest, insert the numbers on Pages 134 and 135, and use those to extrapolate the in-between values, until you find exactly the color you want. There is enough room between all the Bourges colors and tints to create a virtually unlimited range of hues.

This method is demonstrated in the example shown on this page, which starts with nine blue squares from the master chart. The chart below has been expanded to include many additional codes for new hues positioned between the original colors. Now there are 25 blues where there were only nine.

Existing codes page 143, (others are extrapolated).

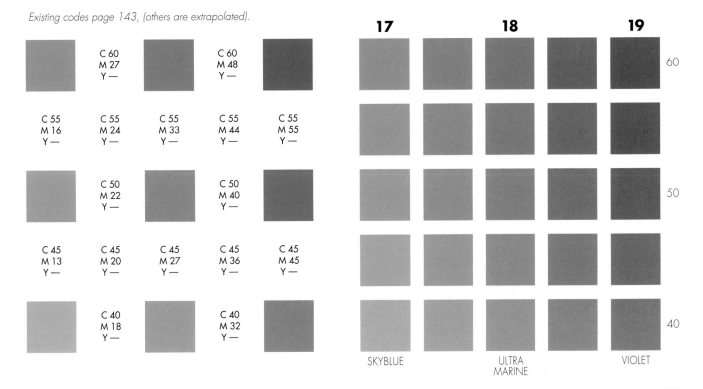

	C 60 M 27 Y —		C 60 M 48 Y —		**17**	**18**	**19**	
								60
C 55 M 16 Y —	C 55 M 24 Y —	C 55 M 33 Y —	C 55 M 44 Y —	C 55 M 55 Y —				
	C 50 M 22 Y —		C 50 M 40 Y —					50
C 45 M 13 Y —	C 45 M 20 Y —	C 45 M 27 Y —	C 45 M 36 Y —	C 45 M 45 Y —				
	C 40 M 18 Y —		C 40 M 32 Y —					40
					SKYBLUE	ULTRA MARINE	VIOLET	

What Are Split Complements?

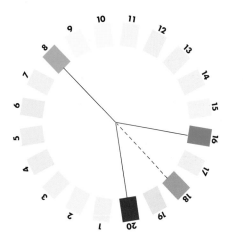

So far we've talked about pairs. Here is how you can still keep the opposing effect of complements when you need three colors. This concept, shown at left with the circle diagram, works for all the colors in the system.

First find the true complement of your hue; then move one, two, or more spaces away on either side. This will give you not one but two opposing colors to use in combination with the original hue. For more about complements, see Chapter 5.

The structure of a good color scheme is creating balance from which you can move lighter, darker, or even shift the colors to get a special effect. Remember this as another simple chromatic pattern to help you make the best combinations.

Six-Color Expanded Palette

BOURGES 1920
Primary and secondary colors shown on label for Bourges engraving company, with the same colors for the agencies and printers alike.

Artists have long accepted red, yellow, and blue as the primary colors and orange, green, and purple as the secondary hues. On the other hand, printers concentrated on the colors that would create the most combinations, *cyan*, *magenta*, and *yellow*, for which they established precise color matches.

It is time for the artist to accept the process colors and for the printer to offer a set of secondary hues that will extend the process gamut to improve the fidelity of color using reproduction. A solution is offered at left, using process colors as the base and adding three other hues to create a wider color gamut.

This is done by adding another triad of *coral, sea green,* and *purple* in between the process primaries *(see color circle at left)*. It will expand the spectrum and create a richer range of colors. Of these six colors, perhaps only one or two is needed. By adding *coral,* even the subtlest flesh tones of a blonde fashion model can be matched. Adding a middle green will preserve the most delicate foliage of a garden catalog. This system is planned to grow.

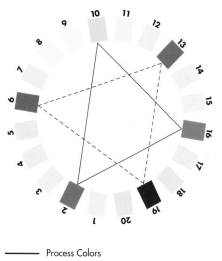

———— Process Colors

- - - - - Secondary Colors

The Magic Is Real

No matter how much we learn about color, it seems there is always more to know. Chevreul explained simultaneous contrast, but no one is sure why the top row of colors at left appears so different from the bottom row when they are exactly the same. The only difference is that the colors on the top row are on yellow lines and those on the bottom row are positioned on navy lines.

While machines can accurately measure small areas of color, the mind sees color relative to its surroundings. Color perception is affected by size, surface texture, other colors, and, of course, lighting.

ARTIST Joy Turner Luke

Note how the colors of Mosaic #1 MAUVE, from Page 140, appear to change when different backgrounds are used.

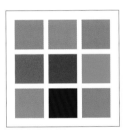

White Backround *50% Gray Background* *Black Background* *Color Background Sky Blue*

Light Changes the Colors

Have you ever matched a color in the store and were later surprised to see how different it looked outside? Since light is the source of the color that is reflected, it remains the prime factor in how we perceive color; see images at right.

Artists traditionally preferred north light. The quality of the light was more uniform and the studio was cooler. When artificial lighting came into the home, tungsten light bulbs produced a warmer light, more similar to candlelight and more flattering to the occupants.

For graphic arts, a compromise was made when D 5000 was established for the industry by ANSI in 1972.

STORE
*Cool White
Fluorescent
North Light*

GRAPHIC ARTS
*D 5000
International
Standard*

HOME
*Warm Light
Tungsten
Incandescent*

GTI -Graphic Technologies Inc. ©

These three images are exactly the same, but viewed under three different lighting conditions. Even in this small size, note how the backgrounds and flesh tones have visually changed.

Signature Curves
of Bourges Colors

Technology recognizes color by numbers and curves. These individual images are shown in Chapter 2, at the bottom of each profile page. Seen here together a basic pattern emerges, which is helpful to know. Note that the curves gradually change shape, with the last one connecting to the color at the beginning.

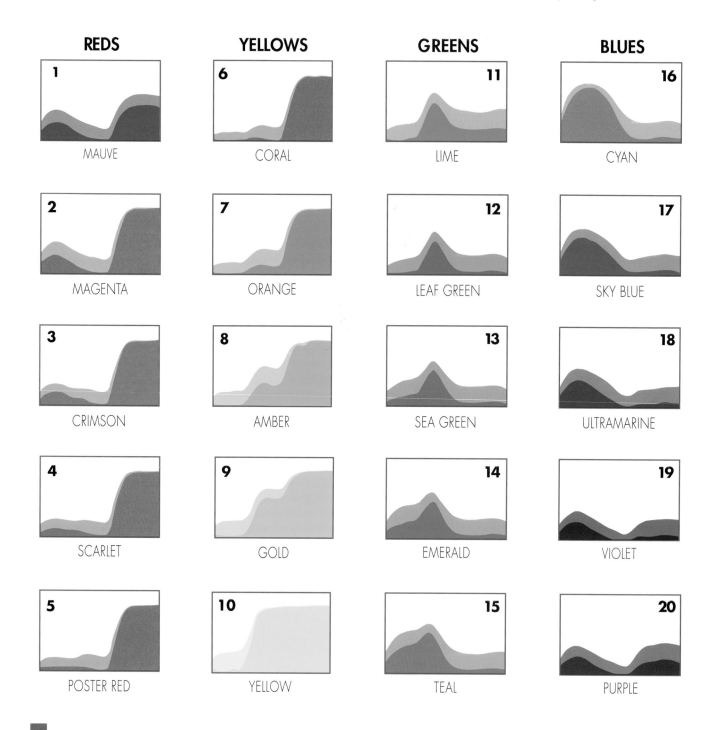

REDS	YELLOWS	GREENS	BLUES
1 MAUVE	**6** CORAL	**11** LIME	**16** CYAN
2 MAGENTA	**7** ORANGE	**12** LEAF GREEN	**17** SKY BLUE
3 CRIMSON	**8** AMBER	**13** SEA GREEN	**18** ULTRAMARINE
4 SCARLET	**9** GOLD	**14** EMERALD	**19** VIOLET
5 POSTER RED	**10** YELLOW	**15** TEAL	**20** PURPLE

Color Blindness

One important factor about color is how we perceive it. Scientists and color specialists have made progress in measuring and codifying color, but the human perception of color may be more elusive. In ancient times, Plato wondered if hues looked the same to everyone. Of course, they don't. Yet while there are truly color blind people who see no color at all, fortunately, they are rare. However, many people have some type of color vision defect.

Early in my career, I had an important client who one day said to me, "That's exactly the color I want, green!" Of course being young and knowing better I responded that the color wasn't green, it was blue, and the next day I brought him some blue sheets to show the difference. But all I got was a lesson in artist/client relationships. "Don't tell me what I see; those colors are gray!"

Sex is a Factor

Age and illness can affect color vision but the main causative factor is the x chromosome. Color vision is an inherited genetic condition, an integral part of your DNA and does not change in your lifetime. Talent, skill and experience are not involved; all you can do is accept and learn to live with your individual spectral vision. One in eight men, statistics show, have some type of a defective color gene. That is 12% of the male population and possibly includes your client, printer, production associate, and perhaps even yourself. Women have two x chromosomes (xx) and fare much better in the color-blindness statistics, which improve to only one in 200.

You must take a color test to get a license to drive a car, sail a boat, or join any of the armed forces. So if your work includes any type of critical color matching, you should know the quality of your color vision and the colors you either see or don't see. This can be quickly and easily determined by a trained professional.

Courtesy of Professor Douglas Ford Rea, Rochester Institute of Technology
FROM Esprit `94, *Medium Under Mind*

Many series of test images are available to determine any specific color anomaly that may exist. Dr. Jay Cohen, professor, New York State College of Optometry (SUNY), has given much assistance in the preparation of this material and is exploring plans to include artists, particularly students, into the college's testing programs.

How Many Squares Do You See?
In good daylight, place this image directly in front of you. Look at it for just a few seconds and the squares will appear. This is the Farnsworth 2, Naval Research test image for the mass screening of color vision.

(Answer on Page 159.)

Image courtesy of Dr. Joel Pokorney, Ph. D., University of Chicago

Production Notes

When I started in the art profession, transparent red overlays were the staple tool of art production. My father pioneered this product in the 1940s. Bourges Transopaque and Cutomask are names that some of you may remember. Before then, masking overlays were painted by hand with black opaque. It worked, but the transparent red accomplished the same thing and was much easier to work with. You could see through the transparent overlay to check accuracy. This color reproduces the same as the opaque black on ortho film.

How This Began

After I gave a presentation to the ISCC (Inter-Society Color Council) in Cleveland in 1990, my thoughts were well received and the idea for a book was born. *Color Bytes* started as "Color Basics" and was created as a visual dummy; the text came later to explain the illustrations. Without the computer and digital technology, this book would never have been published. High-tech accuracy is now a reality, and my 50 years in art production have become a very valuable asset. In printing, as in anything else, achieving high quality is not a problem if cost is not a factor, but I wanted this book to be available for students at a reasonable price. Finally, with the cooperation of many

in the graphics industry, this book has taken shape.

Copies from Heaven

Throughout this production, I could not help wondering what it would be like if excellent color copies were not readily available. Not long ago, artists' comps were handmade, time-consuming, and difficult to produce. The early color copies were helpful, but colors and detail left much to be desired.

Copier technology has greatly improved and the images are more like color proofs; in most cities, they can be supplied in multiple copies any time of the day or night. These are very helpful to the artist, enabling layouts to be changed and improved at all stages of production. In the past, such changes had to wait for the color proofing stage, and by then revisions were costly and done only when necessary.

Prepress Strategy

The production of this book proved that this new system worked. With art as the framework, planning was critical and each page was explored with the printer. Cost was also a factor. The budget did not allow for unnecessary changes or extra production costs. The quality of the color match was also vital in determining whether commercial or open systems would be used. This is

not the kind of work that only a few specialized printers can do, but rather work that can be done anywhere in the world where these production standards are in place.

Screening

This book was produced with conventional 200-line screening. While finer screens will hold more detail, this one is the most popular and the quality is very good.

Benchmarks in Color Space

These Bourges colors are predictable; the CMY numbers are shown on Pages 134-135. For other applications, additional colorimetric measurements are available, such as xyz, lab, and RGB, etc. See the last page in this book for availability. The working modem for the colors described here will work anywhere.

Production Prepress

While overlays and masking are no longer used, the capabilities of the new digital equipment are awesome. Almost everything that was too difficult or expensive before can now be done quickly and accurately.

PostScript has become the accepted standard language for open systems. This ties everything in together, from the high-end systems, which are fast, sophisticated, and expensive, to the once-lowly personal computers,

133-Neg.
K C M Y

GATF/SWOP
PROOFING BAR

which are catching up in speed and capability at much lower cost. What started out as a competition is now bumping along as a marriage of convenience.

Proofing Is Insurance

In the corridors of current print technology, there is talk that since colors and imagery are now converted to numbers, color proofing is no longer necessary. But committing a print run of any quantity without seeing a color proof is a big risk and one I would not take.

Precise mathematical accuracy is possible, but that is not the goal of graphic arts. The qualities of colors transcend those of numbers. Colors change visually when they're placed next to other colors, and large and small areas of the same color appear different to the viewer. As a result, the art the customer initially approves may not be to his or her satisfaction when it is on the selected paper in the actual inks. For this reason, quality prepress color proofs prevent expensive trouble, ensure successful results, and guarantee a satisfied client.

White Is the Paper

No color will be brighter than the whiteness of the paper it is printed on. As a practical matter, the paper choice should always be made in consultation with your printer. Problems on the press with curl or other paper pitfalls are costly. To avoid these glitches, choose the best paper you can afford, one your printer feels confident in using.

There is no such thing as a pure white paper, one with no color at all. Instead, paper is made in a variety of white hues for different markets. For example, in the United States, West Coast clients prefer a warm white paper, while cool whites are more popular on the East Coast. To meet the needs of the widest audience, a balanced white was used for this book.

International Process Inks

As of this writing, the ISO standards committee has approved the initial document for an international set of process inks. In the past, we had ours, Europe and Asia had theirs; now at last there is an agreement that will be recognized worldwide. These #2846 process inks are used in the printing of this book.

Ink has always been the color base for the Bourges systems: in 1918, for the notation chart; in 1947, for the color sheets; and now at the close of this century, for this digital color system. My father believed that accurate ink match was the ultimate goal of color print technology; this is what all the progress in color standards research has accomplished.

Multicolor Presswork

Paper or any other carrier sheet can be run through a press many different times. But this is costly, so most professionals try to reduce these press runs to a bare minimum. Hence, there is a growing interest in CMYK process printing – which provide more colors for less money – for everything from office copies, to textiles, newspapers, magazines, and displays. *Color Bytes* is printed on a six-color press, consisting of the four CMYK process colors, one special color for the page dividers, and a varnish, which is printed only over the color illustrations, not the charts.

Shown at the bottom of these pages are the popular GATF Color Control Bars. They were used across the full width of each printing form, to monitor dot gain, ink densities, trapping the overprinting, etc. This control is necessary to maintain the quality of high-tech process printing.

Regardless of the equipment used, following these guidelines will improve your color match. Then as you upgrade the machines, it will get even better. Enter this new window and color control is yours.

133-Neg.
K C M Y

GATF/SWOP PROOFING BAR

0123456 7

Standards Are Here
SWOP® Calibration Charts

In today's world of electronic color separation, electronic data exchange, and color calibration, the color technologist also needs to be able to map the relationship between the input CMYK data or dot values and the printed color or output. This mapping is often referred to as "color characterization."

In the late 1980s, the American National Standards Institute's graphic arts standards committee, ANSI/IT8, recognized the need for a reference set of CMYK data that could be used consistently for color characterization. With the help of the major electronic prepress manufacturers, a data set was created to meet this need. This data set is known as American Standard IT8.7/3-1993. Graphic Technology-Input Data for Characterization of Four-Color Process Printing. The same data set is also contained in International Standard 12642, which has the same title. One layout of this data set is shown in the SCID data charts on the facing page.

It is important to note that these standards also include specific requirements on the measurement geometry and colorimetric computation procedures. That is necessary to allow resultant data to be exchanged between graphic arts color-management or calibration systems. Measuring color is as complex as perceiving it. A number

of critical steps are involved in enabling the color selected by the designer to be properly reproduced by a printing press or other color proofing or printing devices. The IT8.7/3 data set is being used in both the United States and internationally by trade associations, standards committees, and technical institutes to characterize various broadly accepted and/or standardized printing conditions. In addition, it is becoming the tool used by color-management systems to characterize specific presses or CMYK color printing and proofing devices.

Within the United States, another ANSI committee, CGATS (Committee for Graphic Arts Technologies Standards), has made such characterization data publicly available. Currently, the characterization data for SWOP (Specifications for Web Offset Publications) press proofing is in an ANSI Technical Report, ANSI/CGATS TR001-1995.

SWOP is the proofing specification currently used by virtually all U.S. publications to ensure that all advertisements submitted will print consistently. This specification also applies to magazines printed by web offset or gravure. The availability of such characterization data is allowing the manufacturers of color-separation systems and color-

management systems to provide consistent relationships between a desired color and the CMYK data needed to produce that color in a specified printing process.

The physical representation of the IT8.7/3 data set, on the facing page, was printed along with the rest of this book. Therefore, it could not be measured ahead of time to allow the color characterization information to be included as part of the text. However, the printing conditions for this book are expected to be very similar to the color characterization data for SWOP printing that has been characterized and reported in an ANSI technical report.

For those who wish further information on the color characterization of this printing of the data set, the input halftone dot values used are included on Pages 134-135. The printed image can be measured with a spherophotometer and the appropriate tables of colorimetric output vs. input dot values can be constructed. Using simple interpolation techniques, such characterization data can enhance the selection of the input dot values required to produce selected output colors. In addition such data can be used to create a "color profile" for use in a color-management system such as those associated with the International Color Consortium (ICC).

S8

S7

▲ S9

SCID: Color Chart S7, S8, S9, S10

S10

Process-Color Space

In print, this is called a set of progressives and is valuable because it shows the separate image for each process color, so that you can see how this system is constructed. At right is the composite chart. The individual colors are shown below. Cyan is at the right side of the chart, the magenta is at left and the yellow in the middle. The 2-color image combinations are shown at the lower right.

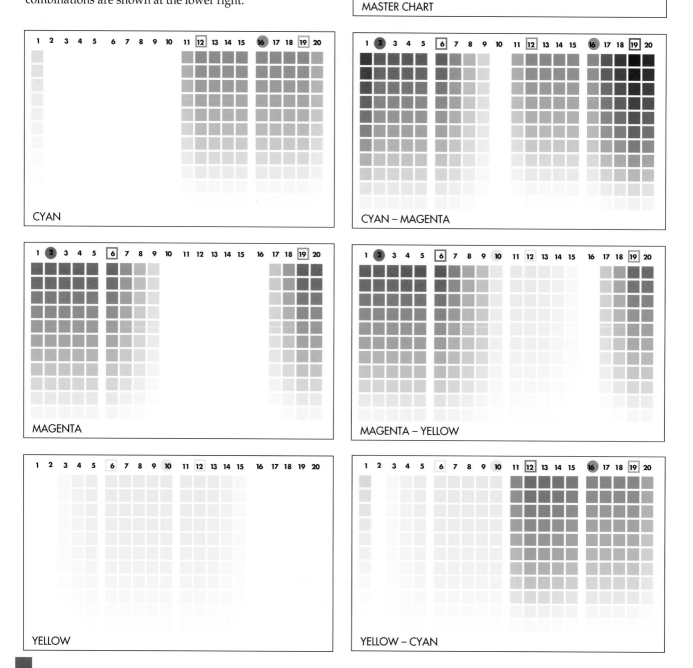

MASTER CHART

CYAN

CYAN – MAGENTA

MAGENTA

MAGENTA – YELLOW

YELLOW

YELLOW – CYAN

With or Without Dot Gain

While it is technically possible to show the print without dot gain, the production process existing in the majority of printing plants make dot gain a part of every print piece.

Dot gain standards established by CGATS were the basic parameters for this test. When an ink dot contacts paper, expansion does occur. This expansion can be controlled and measured, with the only noticeable differences occurring in the middle tones (strength) of ink. Full ink coverage areas and light ink coverage areas produced no visible changes.

Digital pre-press and computer enhanced presses provide a greater degree of control over the variations in dot gain. While there is not set figure, the amount of acceptable dot gain ranges from 17% to 22%. Each printing project will differ due to the interaction between a specific ink, paper and press. Most important is to maintain consistency of dot gain throughout the entire press run.

Dot gain does not affect the artist nor should it influence how colors for printing are specified. Dot gain is an inherent part of the printing process and discussed here to bring an awareness to the artist of its presence in graphic arts technology.

C		M		Y		K	
PROCESS CYAN		PROCESS MAGENTA		PROCESS YELLOW		PROCESS BLACK	
16		2		10		(Gray)	
A	B	A	B	A	B	A	B

A– With Dot Gain (file dot on film, CGATS standard)
B– Without Dot Gain (adjusted, file dot on paper)

For Your Reference

This chart shows two tonal scales for each process color. One marked "A", with the dot gain, the file dot on film, that was used to print all the colors in this book. Another marked "B" which the printer has artificially adjusted the halftone dot structure to show no dot gain but rather the visual effect of file dot on paper. This was done in order to provide a comparison. Look closely and you should be able to see the slight increase in the middle tones of the first images. Not much, but it is there and now you know what it looks like.

Anatomy of the Squares

COMPOSITE CYAN MAGENTA YELLOW

REDS

This red square is the only one that includes all three CMY hues. All these colors have 100% *magenta* as their base color. There is a touch of *cyan* as the support color for the *mauve* at the edge. Next comes pure *magenta* and then *yellow* is added, increasing to almost full strength at the center.

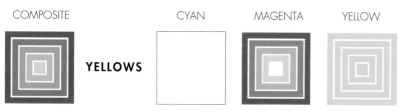

COMPOSITE CYAN MAGENTA YELLOW

YELLOWS

The simplest square and the one you see first has 100% *yellow* as the base color. The edge has equal amounts of *yellow* and *magenta*. From there, the *magenta* gradually lightens, disappearing completely in the center square. There is no *cyan* in this square.

COMPOSITE CYAN MAGENTA YELLOW

GREENS

This square is quite different from the others, as both *yellow* and *cyan* play similar roles. The *yellow* is strongest at the edge, lessening toward the middle, while the *cyan* is the strongest in the center. This is a beautifully balanced square with no *magenta* in any of these colors

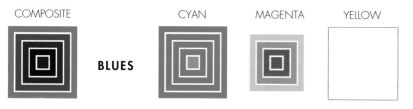

COMPOSITE CYAN MAGENTA YELLOW

BLUES

Here the main ingredient is *cyan*, the blue of the process colors and the prime hue until the *magenta* takes over in the center square. The redder purple makes a better connection with the *mauve* of the first color square. There is no *yellow* in the last square of the system.

About the Cover

Shades of Colors

A gray tint has been added to the colors of the letters above, which adds depth and holds the word together (See Chapter 3).

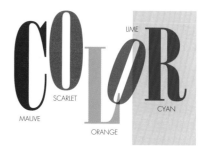

Fuzzy Colors

The squares below are the flat tints from the back cover, with the process codes that were used. These are blends, the soft muted hues described on Pages 140-141.

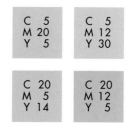

The base color for each square holds the middle position in all four color groups and establishes the natural chromatic balance.

This concept of multicolor harmony is described in Chapter 6. The full tonal scales, image, and story are shown for the pure four colors on Pages 138-140.

Put the Colors in Your Pocket

Correctly identifying a color by its appearance is very important, not just in this book but wherever you are. Cut yourself a strip along the right edge of this page. Fold in sections and carry these 20 Bourges colors with you. Cut another strip and place it where you can see the colors as the light changes. Then you will see for yourself which color is the first to disappear at twilight.

Pay attention to the colors around you, in clothing, decor, advertising, displays, etc. If the color is green, which green? Then take your strip and compare. Matching a color in isolation is not easy. It always helps to see other colors to find a hue's exact position in the spectrum. Check yourself and do this as often as you can to improve your color skills.

If you have access to a museum or art gallery, drop by and take a little time to scan the images, not for the subjects but the colors. Which did you see first? It would probably be a red, but which red? Where is the yellow? Most eyes seem to search for it; do yours? What color do you like best? Remember, this has nothing to do with the subject, only your personal response to the color.

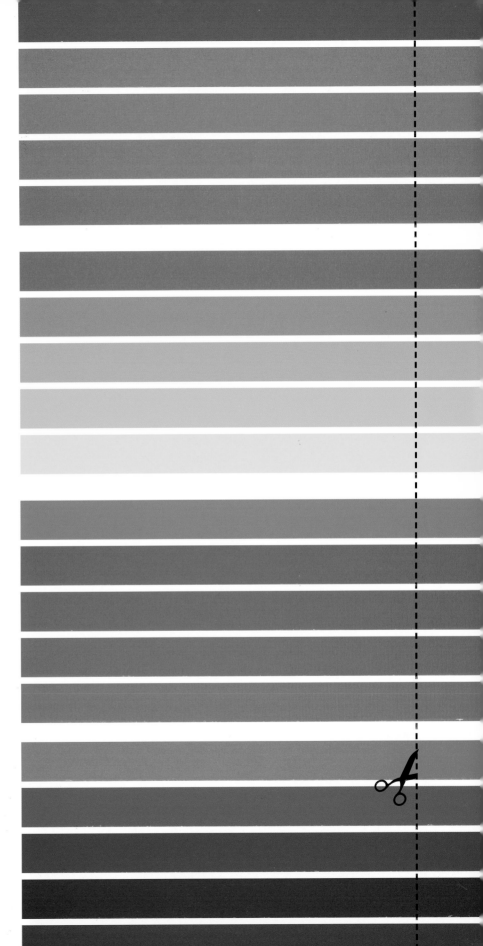

| 1 MAUVE | 2 MAGENTA | 3 CRIMSON | 4 SCARLET | 5 POSTER RED | 6 CORAL | 7 ORANGE | 8 AMBER | 9 GOLD | 10 LEMON |
| 11 LIME | 12 LEAF GREEN | 13 SEA GREEN | 14 EMERALD | 15 TEAL | 16 CYAN | 17 SKY BLUE | 18 ULTRA MARINE | 19 BLUE VIOLET | 20 PURPLE |

Learn – *what others are doing with color. Concentrate on the big-budget corporations. They spend the most and hire the best designers to select colors. Watch their current advertising on television or in print. Get some of the excellent graphics annuals filled with award-winning work and review it often to learn from the leaders in the field.*

Study the masters – *many of whom had to make their own paints so they were very careful with their color choices. There are affordable books on the market with very fine color reproductions of great artists; collect some. Find an artist whose work you admire and search for additional works in postcards, prints, and other books. Study the similarities and the differences.*

Clip magazines – *looking just for color concepts, save everything that interests you. Then when you have some quiet time, study the clippings carefully, keeping only those you want to remember. Later you can divide these clippings into different color groups, individual hues, related colors, complements, etc. Make this the start of your own personal color-reference library and an ongoing source of inspiration.*

Visit an art store – *particularly if your background has been in color science. Buy a sketch pad and a few colored pencils that closely match these 20 colors. Try working out your ideas on paper. Explore the connections between working with pigments and working with the digital screen. Experiment with color in many ways, whether it's in art, film, computer, imagery, or the printed page.*

Index

Artists and Photographers

Color Image Credits (page 118) 2, 3, Courtesy of Birren Collection, Yale Art and Architecture Library; 4, Macbeth, Division of Kollmorgen Instruments Corp.; 5, Bourges Collection; 6, Winsor Newton

Stock Photo Credits

Corel Corporation 10, 11, 42, 58, 110
The Corel Building
1600 Carling Avenue
Ottawa, Ontario, Canada K1Z 8R7
Tel: (613) 728-8200 Fax: (613) 761-9176

Digital Stock Corporation 45, 71, 160
400 South Sierra Avenue
Solana Beach, CA 92075-2262
Tel: (800) 545-4514, (619) 794-4040
Fax: (619) 794-4041 E-Mail:
sales@digitalstock.com
Web: http://www.digitalstock.com

Image Bank, Inc. 47, 88, 107,112, 127, 129
111 Fifth Avenue
New York, NY 10003
Tel: (212) 539-8300 Fax: (212) 539-8391

John Foxx Images 78, 79
157 East 57th Street
New York, NY 10022
Tel: (212) 644-9123 Fax: (212) 644-9124
and Riverstaete, Amsteldyk
166-1079 LH
Amsterdam, Netherlands
Tel: (31) 20-6448842

Image Club Graphics 88, 104
A Division of Adobe Systems, Inc.
Suite 800, 833 Fourth Avenue SW
Calgary, Alberta, Canada T2P 3T5
Tel: (403) 262-8006 Fax: (403) 261-7013
Web: www.imageclub.com

Photo Researchers 50
60 E. 56th Street
New York, NY 10022
Tel : (212) 758-3420 Fax: (212) 355-0731

Planet Art 10, 12, 27, 121,
2814 Main Street
Santa Monica, CA 90405-4010
Tel: (310) 399-5110

Tony Stone Images/New York 55
475 Park Avenue South
New York, NY 10016
Tel: (212) 545-8220 Fax: (212) 545-9797

Color Blindness Solution

If your answer was two, you were right, but the real answer is three; note the interlocking square between the two bigger ones. Original on page 147.

Credits and Acknowledgements

About the Desktop

"During the two-and-a-half years I worked on this project, the technology was literally exploding around us, in the midst of design and production. By creating 95% of the charts in my page layout program, I can say it was pushed to the limit of its capabilities with custom colors, styles, and fine-tuned controls. It's a pleasure to see the project come to fruition."

Marilyn Scheyer, Multi Media Design

About the Printing & Production

"Projects that challenge people to exceed their present capabilities and to test the limits of technology are rare ... and exciting! **Color Bytes** *presented just such a challenge. Jean Bourges' vision, and a belief in her ability to turn that vision into reality, became the driving force of* **Color Bytes**. *Her spirit and dedication provided a platform for our creative people to reach new levels ... and to expand current levels of how digital technology may be employed. Each step of our graphic arts process has benefited by being a part of* **Color Bytes**! *From digital proofing, computer enhanced presses and just good old-fashioned craftsmanship, Jean has helped us to achieve new levels in all areas. It has been great to be a part of this project and to work with all those who contributed to turning this dream into a reality!"*

Richard Yeats, Owner, Quality Graphics

About the Proofing

"Imation's Rainbow™ proofing system is the color proofing system of choice for **Color Bytes.** *The critical color matching, flexibility and short proofing cycles made the Rainbow proofs an indispensable production tool. I wish Jean great things at the end of every rainbow!"*

Bill Martin, Imation Corp.

About the Inks

"When Jean first came to us with the **Color Bytes** *project, it was immediately evident that accurate color reproduction would be critical. We were very pleased she had selected Superior's Super Tech process inks for this important project. These high performance #2846 International process inks are among the finest products available today, delivering low and balanced dot gain and extraordinary on-press stability.*

Harvey R. Brice, President, Superior Inks

About the Paper

"Because accurate color was of the greatest importance for the production of **Color Bytes**, *Jean Bourges needed a paper that would reflect the full color spectrum. We're very pleased that Quintessence Dull by Potlatch was the paper choice. This balanced white, acid free paper provided the ideal combination of easy reading and crisp, accurate color reproduction necessary to do justice to this benchmark publication."*

Carole Branagan, Potlatch Paper Corporation

Our appreciation to the following companies and organizations who have graciously contributed images and support for this project.

AARP • American Museum of Natural History • Artists Rights Society • Beth Israel Phillips Center • Bonwit Teller • Brooks Brothers • Mairie de Bourges • CBS News • Carnegie Museum of Art • CGATS • Chemical Heritage Foundation • Chermayeff & Geismar, Inc. • Condé Nast Publications, Inc. • Cook and Shanosky Associates, Inc. • Crate and Barrel • Daler-Rowney USA • Domain Home Fashions • Dupont • Dynamic Graphics Educational Foundation • Eastman Kodak • Eaton Corporation • Esprit, Rochester Institute of Technology • GATF, Graphis Arts Technical Foundation • Glassmasters • Golden Artist Colors • Grace Rothschild • Gretag Macbeth • GTI-Graphic Technologies, Inc. • Gucci • Guess Home Collection • IBM Research • Imation Corp. • Kraft Food, Inc. •Lacoste • Lamont-Doherty Earth Observatory • Learning to Read Through the Arts, Inc., Guggenheim Museum • Les Hertiers Matisse • Louisiana Office of Tourism • McCann-Erickson • Mercedes Benz of North America, Inc. • Mikasa • Minolta Corporation • Munsell Color • Musée du Louvre • NAMTA-National Art Materials Trade Association • NEC • Océ-USA, Inc. • Oneida, Ltd. • Parsons School of Design • The Pierpont Morgan Library • Portfolio Center • Potlatch Corporation • Scalamandre Silks, Inc. • School of Visual Arts •Schurman Designs • Scully & Scully, Inc. • Skidmore, Owings & Merrill • Smith & Hawken • Smithsonian Institution • SUNY - College of Optometry • Superior Printing Ink Co., Inc. • Tastemaker • TBWA Advertising • Tiffany & Co. • University of Chicago • Mrs. John Hay Whitney Foundation • Winsor & Newton • Xerox Corporation • X-Rite Incorporated • Yale University •

Not the End
... Just the Beginning

Learning about color is a never-ending
adventure. The more you know,
the more you want to know.
The first step is easy; just open your mind
and become more aware of the
colors all around you...

Think of color knowledge as a continuing
education. Chances are, you first learned
about primary colors with your
elementary-school box of crayons,
eventually graduating to gray values
and to multicolor harmonies in
high school and college.

The goal of this book has been to give
you an updated postgraduate education
in the use of color, enabling you
to create the best color image for
the story you want to tell. Now ...
* come explore, learn and enjoy !*